IMAGES OF ENGLAND

YARDLEY
REVISITED

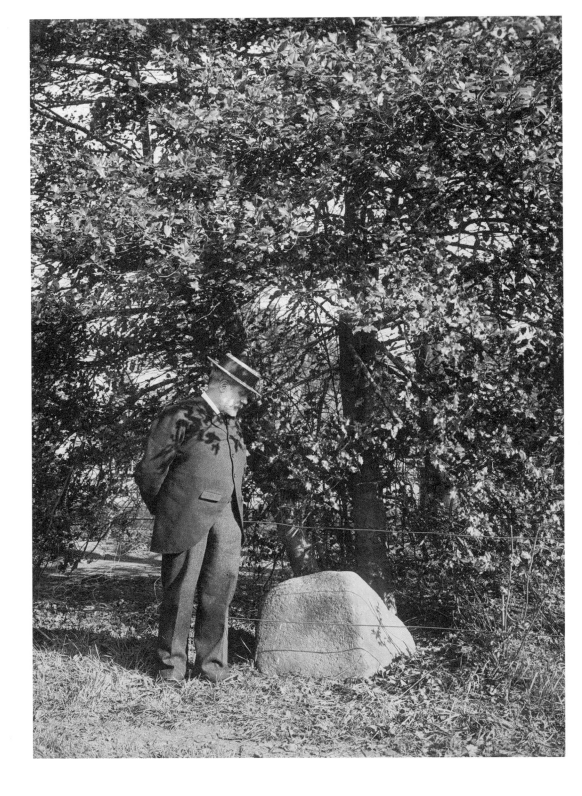

IMAGES OF ENGLAND

YARDLEY
REVISITED

MARGARET D. GREEN

TEMPUS

Frontispiece: George Hookham inspecting the Gilbertstone, an ancient boundary marker in the grounds of the house and estate named after it, 1900.

First published 2007

Tempus Publishing
Cirencester Road, Chalford,
Stroud, Gloucestershire, GL6 8PE
www.tempus-publishing.com

Tempus Publishing is an imprint of NPI Media Group

British Library Cataloguing in Publication Data.
A catalogue record for this book is available from the British Library.

ISBN 978 0 7524 4367 6

Typesetting and origination by NPI Media Group
Printed in Great Britain

Contents

Acknowledgements

The photographs included here are mostly from collections held in the Local Studies Section at Birmingham Central Library. I would like to thank the many people of Hay Mills, South Yardley and Old Yardley who were involved in collecting, copying and taking photographs of the area from 1984-86, while it changed so dramatically before their eyes. Thanks also to Lithograve Ltd for the photographs on pages 80 and 90, to Carl Chinn for page 37 (top) and the Midlands Co-operative Society Ltd for pages 58-63 and 99 (bottom).

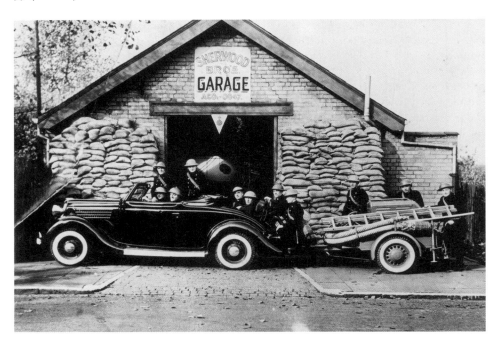

The auxiliary fire station, Geraldine Road, *c.* 1940.

Introduction

This collection of photographs is intended to complement the book by Michael Byrne, published by Tempus twelve years ago in 1995. Mike Byrne's *Yardley* covered the northern part of the ancient and large parish of Yardley, from South Yardley and the Swan, to St Edburgha's church and the old village, taking in Hay Mills and the Hobmoor Lane area. This book will also cover this geographical area, updating some of its history to the 1980s. By 1900, other parts of Yardley, such as Acocks Green, Hall Green, Yardley Wood and Stechford had developed as communities in their own right, and since 1995 have featured in other Tempus publications in this series.

The 1995 collection of photographs illustrated the agricultural nature of Yardley, largely untouched until the 1920s, when the effect of extending the Birmingham boundary in 1911 began to be felt. The inter-war period saw the loss of farms and fields to large municipal and private housing estates, and the loss of the picturesque rural views of the River Cole at Hobmoor ford.

Industrial activity developed at Hay Mills, mainly on the south side of the Coventry Road towards the Birmingham and Warwickshire Canal. Tile and brickworks here made good use of Yardley's clay soil with the canal providing the means of transporting the finished goods. In 1847, James Horsfall moved his wire works from Digbeth to the banks of the Cole, achieving world fame in 1866 for supplying wire cable for the telegraphic line under the Atlantic between England and America. This manufactory still exists, better known as Latch and Batchelor's Wire Rope Works. The tannery which was established in 1802 was taken over in 1884 by George Muscott, after whom it became known. It was one of the last three tanneries in England to still use the traditional oak bark method when it closed in 1966, following the decline in demand for quality leathers for bespoke shoes. There is still some industry here, the brickworks, tannery and engineering works having been replaced by small manufacturing, warehouses and trading estates, benefiting from the closeness of Tyseley.

Since the 1960s, the greatest change has been the extensive widening of the Coventry Road, the A45 in and out of the city, from the River Cole at Hay Mills to the boundary at Sheldon. While benefiting passing traffic, the underpasses at the Swan and Gilbertstone, and the dual carriageway at Hay Mills, have divided the communities

in these areas and made life difficult for pedestrians. It has affected local shopping, particularly at the Swan, where the recent closure of the indoor market and many of the nearby small shops, dating from a 1960s development, has reduced the area to a wasteland. This is such a contrast to the inter-war years when the Swan junction was effectively the cultural and social heart of North Yardley, with a cinema, new library, several pubs, banks and superior shopping. Indecision has reigned for almost a decade on how this area should be redeveloped to benefit the local communities, and by whom it should be redeveloped.

Meanwhile, the much needed widening of Church Road at this point remains on hold, as it has been for the last forty years. Among individual landmarks to have disappeared are several of the large community pubs in the area: the Swan, the Good Companions and the Yew Tree. The Carmelite Monastery has been converted to flats and the first Yardley Grange Home for the Elderly is closed and boarded up. Hobmoor Road Primary School will move soon to much larger new buildings on the corner of Holder Road.

However, in spite of the upheavals along the Coventry Road, there are still many residents who identify with the old communities. The Swan shopping centre development of the mid-1960s was originally named the Tivoli centre after the lost cinema, but locals preferred the Swan, after the pub, and so it became that. In 1995 workmen engaged in landscaping improvements destroyed an old yew tree by which the Yew Tree shopping centre and pub were known. Outraged locals complained and a replacement tree was planted. In 2000 proposed changes to local government administrative boundaries meant that the name Yardley, a place name in use for over 1,000 years, would disappear. Petitions to the Boundary Commission lead to its retention. Changes in local government funding now mean that local people can have a say in how money is spent locally. One result has been the upgrading of the Yew Tree shopping centre, with landscaping, improved pedestrian crossings and that unfortunate symbol of modern times, CCTV.

New play areas with equipment for smaller children have been installed at the Oaklands and Queens Road parks. This part of Yardley is fortunate to have a number of large green open spaces, including three parks – the Oaklands, Queens Road and Gilbertstone – as well as several sports grounds. From the highest point of the Oaklands, there are still stunning views of the city centre. The Conservation Area first established in 1969 around St Edburgha's church and the old village is a reminder of the rural origins of the district. It is only luck that no main road, railway line or canal has come close enough to destroy it, allowing residents and visitors to appreciate the slower world of a century ago.

The observant reader will notice that shops feature a lot in this book. Until the 1960s good local shopping was important. Very few households had refrigerators to store food, and cars were a luxury for the man of the house. Few married women worked and housewives would shop almost every day for vegetables, meat, fish and fruit. Local hardware stores, chemists, shoe and clothes shops were also necessary. City-centre shopping was for special occasions. Local centres like the Yew Tree are still there but where there used to be three or four butchers, grocers and greengrocers, now only one or two might remain, supermarkets having taken the business. The small shops are now occupied by hair and tanning salons, mobile phone suppliers, charities and, of course, estate agents. The big community pubs built in the 1920s and '30s to cater for people moving into the new housing estates had function rooms, bowling greens, darts and snooker rooms, and a ladies' snug. In the age of the car, people travel for their entertainment and these pubs can struggle to survive.

one

Around the
Old Village

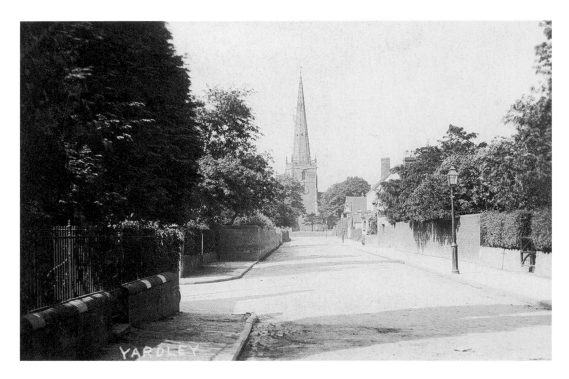

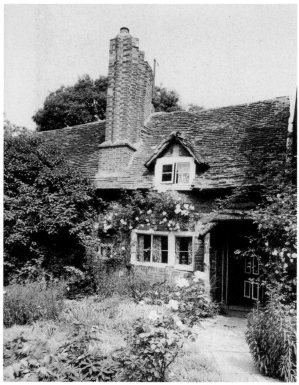

Above: View from the south to the church and village, *c.* 1900. On the left is Blakesley Road, heading downhill across Stoney Lane to Blakesley Hall. St Edburgha's church, then as now, beckons in the curious visitor.

Left: Vintage Cottage, *c.* 1955. This delightful seventeenth-century cottage survived until 1964, surrounded by semi-detached houses at the top of Blakesley Road, just out of sight on the photo above. It was replaced by a two-storey block of flats.

Opposite above: The cosy kitchen with its Victorian iron range, *c.* 1950. Mr and Mrs Beavon were the last occupants of the cottage.

Opposite below: Mary Beavon and her daughter Amy in 1957. The young man was a visiting Scout from Germany, here for the International Jamboree in Sutton Park.

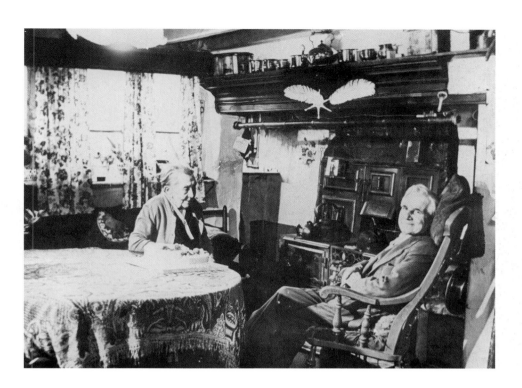

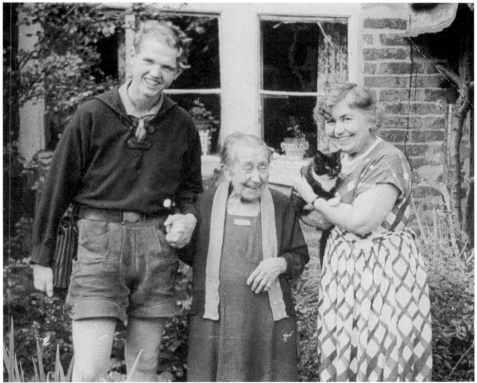

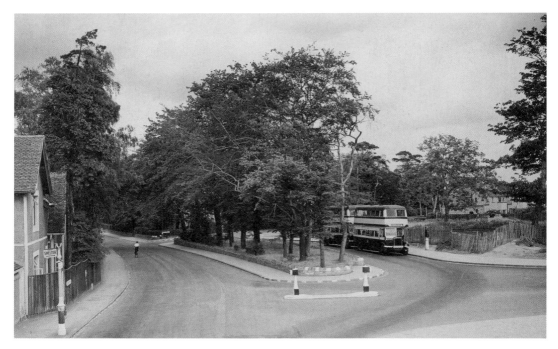

Church Road at the junction with Queens Road, *c.* 1940. The city-centre bus terminated here by the newly built houses. The sign on the left points towards an underground air-raid shelter, with brick air vents which are just visible to the right of the bus stop.

In 1986, sheltered housing for the elderly replaced prefabs built on the shelter site in the late 1940s.

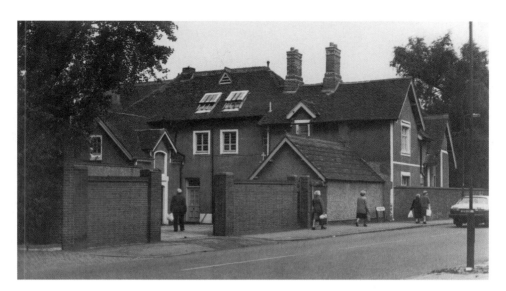

The Grange, Church Road, 1986. Also known locally as the monastery, it was a Carmelite convent from 1933 to 1989. In the early 1900s, it was the home of the Hoskins family, bedstead manufacturers. A complicated building, with many late Victorian additions, parts of it date from the 1600s. Since the nuns left for Wales, it has been renovated and converted to flats.

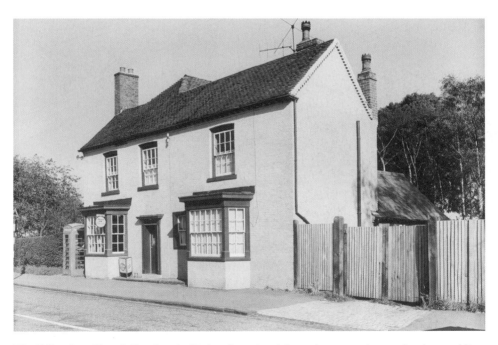

The Talbot Inn, Church Road, 1961. Dating from the eighteenth century, it ceased to be a public house in 1923 when it was sold by Mitchells & Butlers. At the turn of the nineteenth century, it was run by the Barrows family, who also owned land locally, and after whom Barrows Lane was named. Since 1923 it has been a private house, with the front parlour occasionally opened up as a tea room, as seen here.

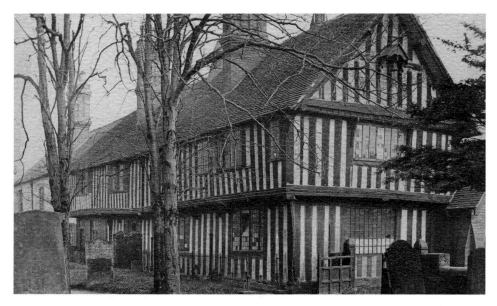

The Old Grammar School, *c.* 1920. Dating from the early 1500s, it was not always a school, and closed as such in 1908. Timber-framed and plastered, it has been much repaired and renovated over the centuries. The school bell is hanging in the gable end. The nineteenth-century brick porch was soon replaced by a more appropriate timber-framed one.

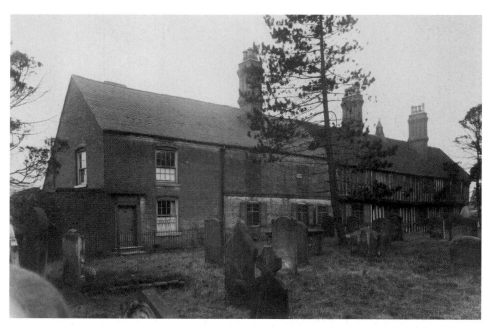

The school and its additional buildings, *c.* 1930. Dating from the early 1800s, the brick-built house on the end was for the schoolmaster. This extension has also been altered and currently has mock timbering and plasterwork over the bricks. It seems a dismal dwelling, possibly due to the closeness of the graveyard, from where monuments were removed in 1959-60.

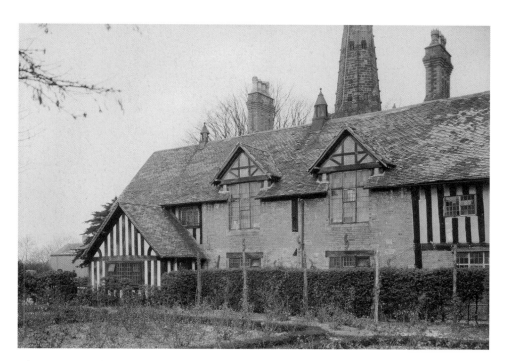

The south side of the school showing the replacement porch, 1950.

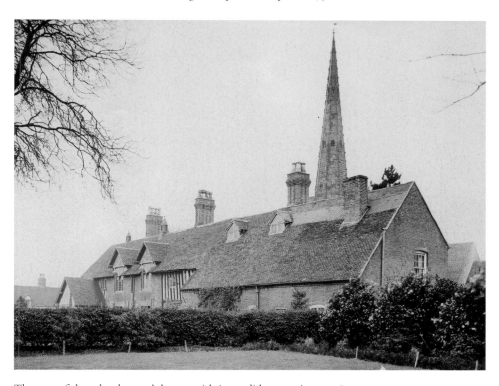

The rear of the schoolmaster's house, with its catslide extension, 1936.

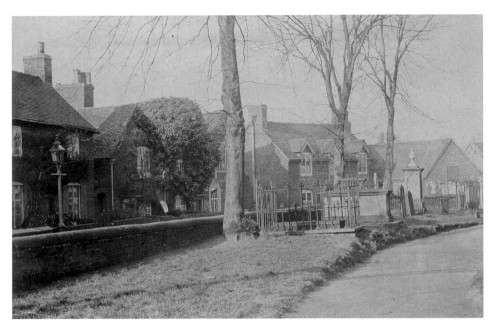

Houses opposite the church, *c.* 1910. On the left is a cottage of 1826, built for the blacksmith, then three terraced houses of 1894, two cottages converted from an eighteenth-century malthouse, and lastly the edge of Yardley Farm.

A similar view in 1973, without the burial monuments. The mix of buildings in the Conservation Area and the lack of motor traffic make it an interesting and relaxing place to walk. The three-storey house on the left dates from 1796 and was a shop until the 1960s. The Cottagers' Institute next door dates from 1882.

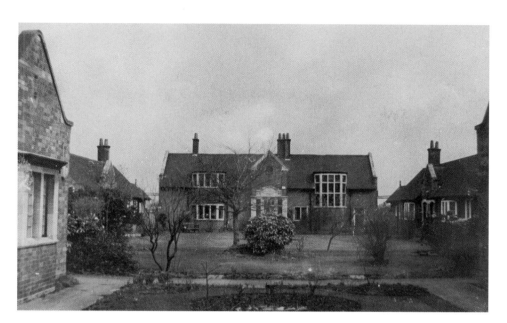

The Almhouses, Church Road, c. 1930. They were built in 1903 to replace almhouses dating from the early 1800s and located near the grammar school. They are owned and run by Yardley Great Trust, created in 1531 to group together the many small charities then existing for the benefit of Yardley people.

The Grange Home for the Elderly, Church Road, 1986. Opened in 1960, it is currently closed and boarded up, being unfit for this purpose under recent legislation, after only forty years. Hopefully any new development will be more architecturally sympathetic to its surroundings.

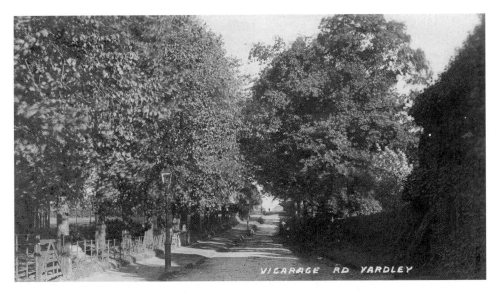

Vicarage Road looking south to Stoney Lane, *c.* 1910. The old vicarage is on the left corner. Church Road from the Swan to Vicarage Road and Yardley Fields Road runs along a high plateau in this part of Yardley which may be one of the reasons for locating the church here. Churchgoers from the south, as well as locals, could avoid the muddy trackways on the lower ground.

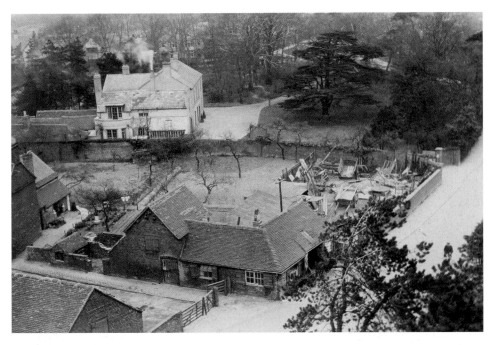

View from the church tower of the corner of Church Road and Vicarage Road, 1935. The old vicarage was a complicated building, originally eighteenth-century but much altered and extended. The smithy in the foreground belongs to Yardley Farm, also known as Tile House Farm. This site has been owned by Yardley Trust since 1463. The farm's outbuildings were restored in 1979.

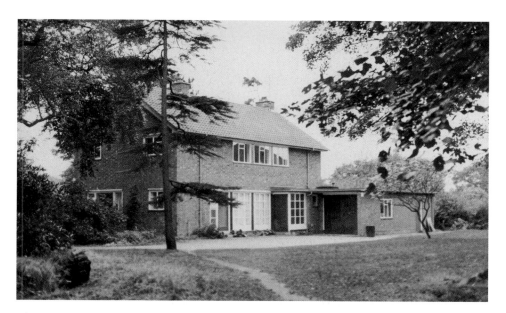

The new vicarage, 1986. This dates from 1960 and replaced the old one, and has now itself been demolished. The vicarages were set in very large grounds which allowed a new and large Yardley Grange Care Home to be built on the site by Yardley Great Trust.

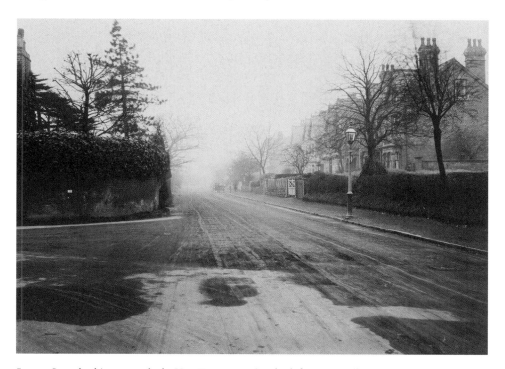

Stoney Lane looking towards the Yew Tree, 1924. On the left is May Villa on the corner of Vicarage Road, demolished shortly after when Stoney Lane was widened for the Outer Circle bus route.

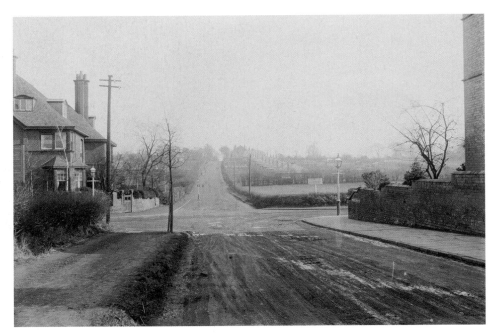

Looking up Yardley Fields Road from Station Road, 1926. Among the trees on top of the hill is the Yardley Arms pub, set among a few early nineteenth-century cottages, which still survive. The view of the new bungalows is today obscured by trees and shrubs.

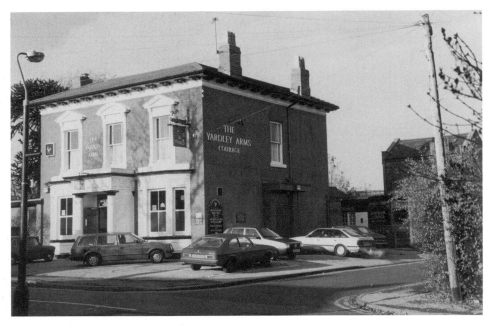

The Yardley Arms, 1986. This was built in the 1840s in a sparsely populated area which had no other inn for the local farm workers. It is now called the Millhouse Inn as yet another historic pub name disappears.

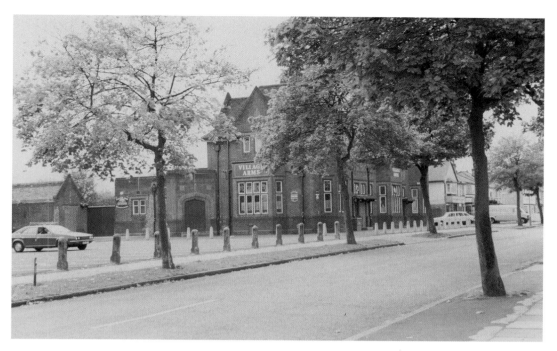

The Village Arms, Clements Road, 1986. An inter-war pub originally called the Blakesley Arms, after the old Hall around the corner, it has been renamed again, and is now the Innishfree.

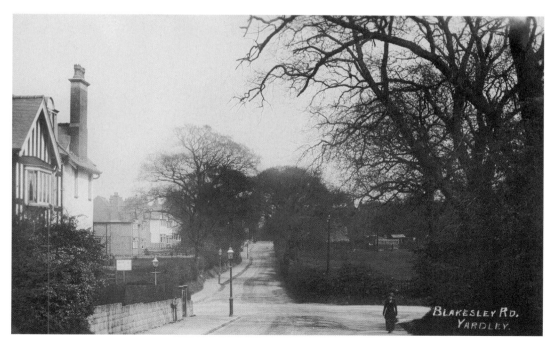

Looking up Blakesley Road, from Stoney Lane to Church Road, c. 1925. At the top of the hill on the left is Vintage Cottage.

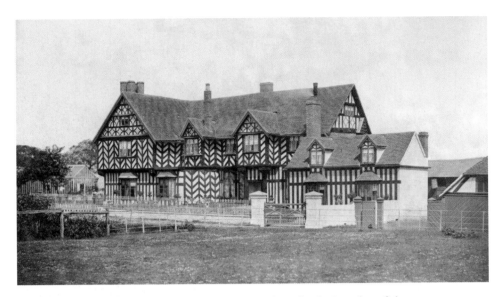

Blakesley Hall, *c.* 1870. It was built in 1590 by Richard Smalbroke Jnr whose father was a
Birmingham merchant. The family's fortune came from dealing in cloth, spices and hardware, and
owning property in the town. Smallbrook Street and Queensway are named after them. Their
wealth was reflected in the amount of timber used in the building.

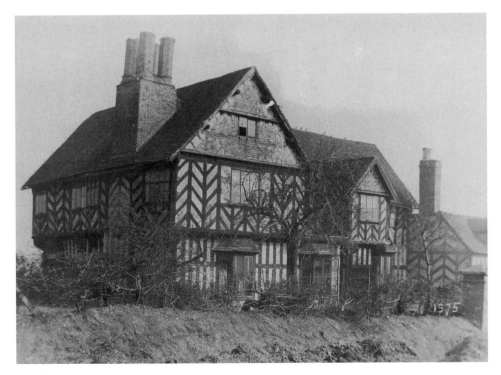

The Hall, *c.* 1895. Owned for two centuries by the Greswolde family of Solihull, it was let to
tenant farmers and fell into serious disrepair.

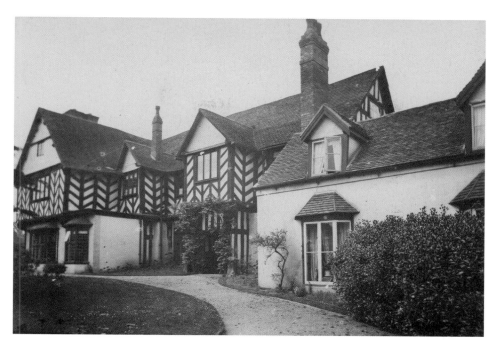

The front in 1932. On the death of the owner in 1932, the Common Good Trust helped
Birmingham Corporation to buy it for the city as a museum, not as a furnished historic house.
The cottage on the right was demolished in 1950 during repair work after the house suffered
bomb damage in November 1941.

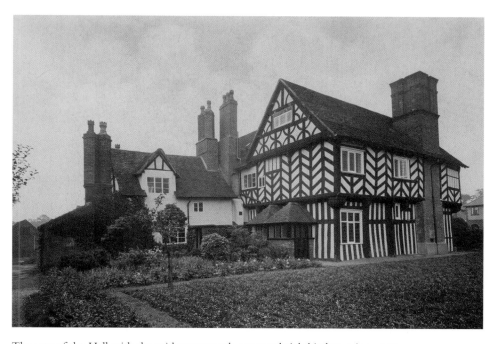

The rear of the Hall with the mid-seventeenth-century brick kitchen wing, 1932.

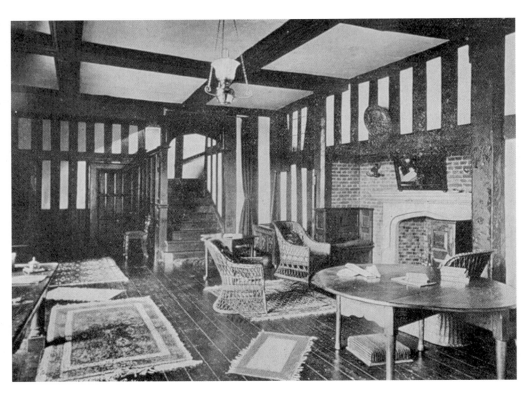

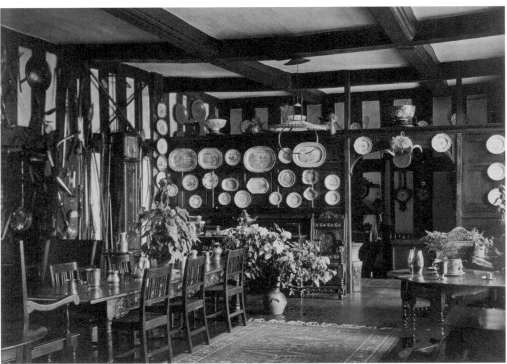

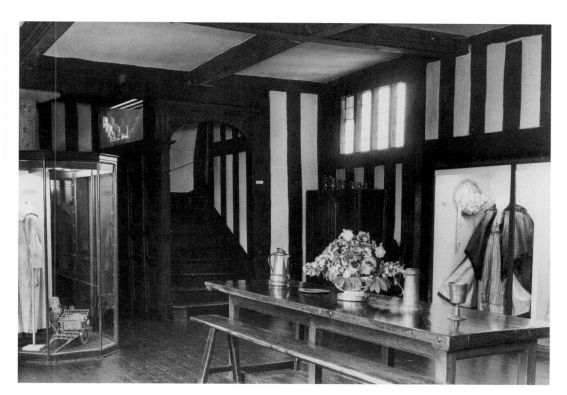

The dining hall in 1957, when the house reopened as a Museum of Manorial Life, with a mixture of social, local history and archaeological displays. Note that the fireplace shown in the photograph opposite has been filled in and glazed over to display costumes. By the late 1970s, it was clear that the Hall was sufficiently important to justify its restoration as an historic house, and slow refurbishment began. Then in 2000, a £2,000,000 full restoration project started, removing modern fixtures and fittings such as radiators and electric lights, and restoring the whole house as a seventeenth-century gentleman farmer's home. Rooms have been fitted out for their original purposes, including the kitchen, parlours and bedrooms, all with appropriate decoration, furniture and objects. Now reopened to the public, it has a visitor centre with space for exhibitions and meetings, and a tea room.

Opposite above: The dining hall, 1900. Henry Donne bought the house from the Greswoldes in 1899 and restored it, selling it on to Tom Merry. He was a paint and varnish manufacturer but also farmed here, and died in 1932.

Opposite below: The opposite end of the dining hall in 1932, showing Tom Merry's furniture, and collection of weapons, china and pewter. The contents were sold separately from the house.

Overleaf: The upstairs gallery, 1983, giving an idea of the style the house now has throughout.

two

St Edburgha's church

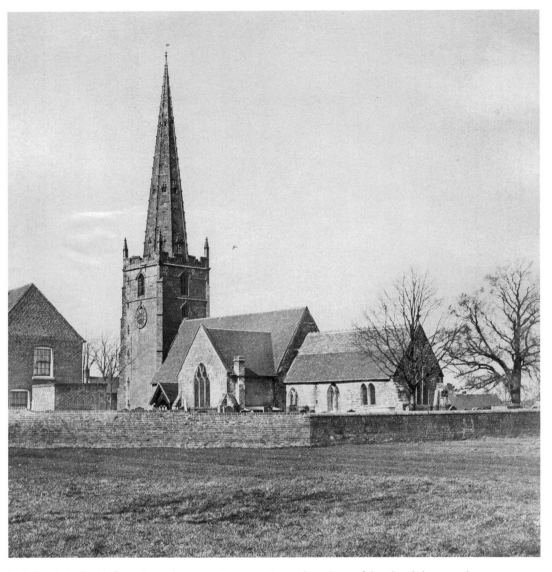

St Edburgha's church from the park, *c. 1900*. In recent times, clear views of the church have not been possible as trees have grown on all sides, especially hollies and yews. It dates from the early thirteenth century and is dedicated to St Edburgha, Alfred the Great's granddaughter.

Opposite above: The view from the north, *c. 1930*. Yardley had been associated with the Bishopric of Worcester since the seventh century but its residents had a long wait for their own church. The most northern part of the parish was not exactly convenient but it was customary to build a church next to the manor house. In the thirteenth century, Yardley's lords were the de Limesi family, living in a moated house nearby. The site of their home is still visible in the park.

Opposite below: The view from the south, obscured by the grammar school, *c. 1930*.

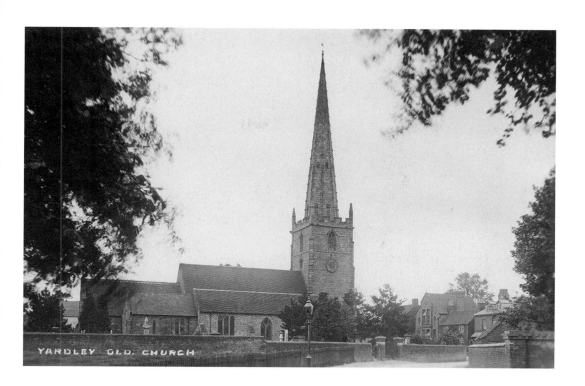

YARDLEY OLD. CHURCH

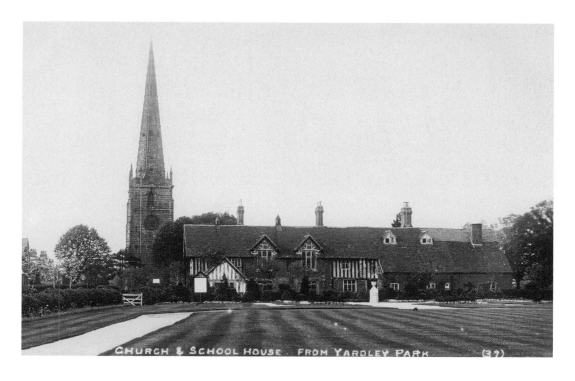

CHURCH & SCHOOL HOUSE. FROM YARDLEY PARK (37)

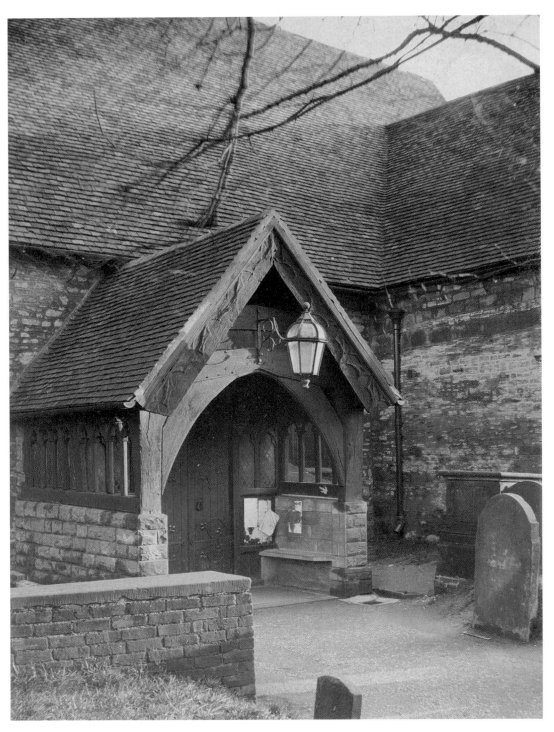

The porch in 1912 as it was meant to be, before wrought-iron gates were added. Dating from the fifteenth century, the oak frame and carved bargeboards have been blackened by the weather and time.

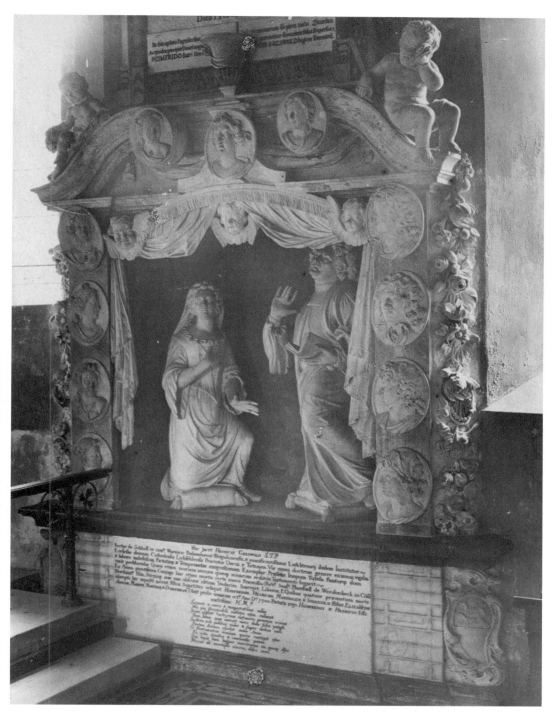

The Greswolde Monument in the chancel, *c.* 1920. This glorious monument is dedicated to Henry Greswolde who died in 1700. The Greswoldes were lay rectors of Yardley and owned land in the parish. Henry and his wife Ann shelter in a curtained recess, surrounded by the medallion heads of their eleven children.

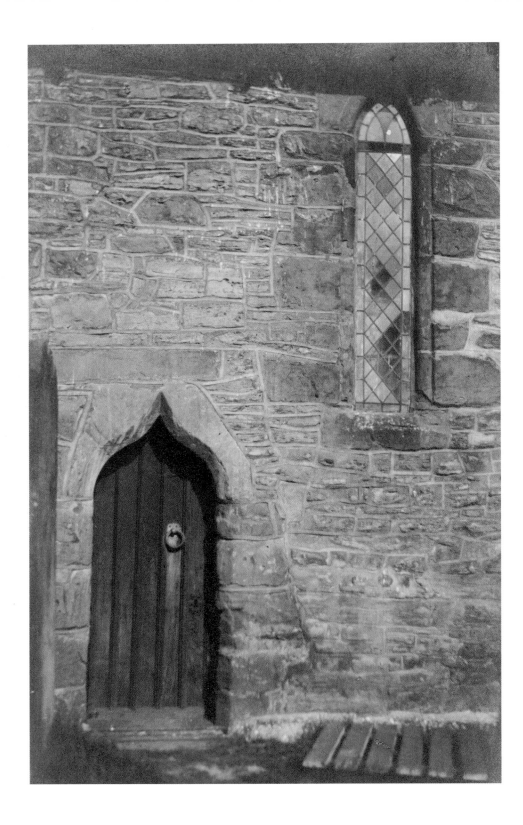

 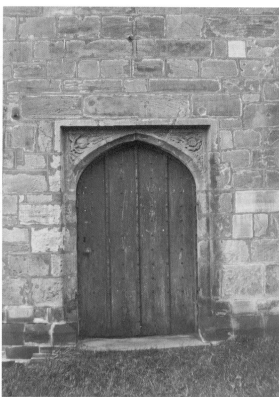

Above left: Looking out of the priests' door to the school, *c.* 1890. This unusual door, with its ogee arch, has been hidden for decades by a small brick extension.

Above right: The rose and pomegranate door in the north aisle, 1912. In 1478 the manor of Yardley reverted to the Crown and was then held for 138 years by eight different monarchs. Yardley was given to Katherine of Aragon as part of her divorce settlement from Henry VIII. The Tudor door is said to celebrate her first marriage to Prince Arthur. The pomegranate is an emblem of Granada, Katherine's birthplace.

Opposite: Priests' door and lancet window in the chancel wall, *c.* 1920. The chancel is the oldest part of the church dating from the thirteenth century. It took three centuries to complete this impressive medieval church, ending with tower in about 1470.

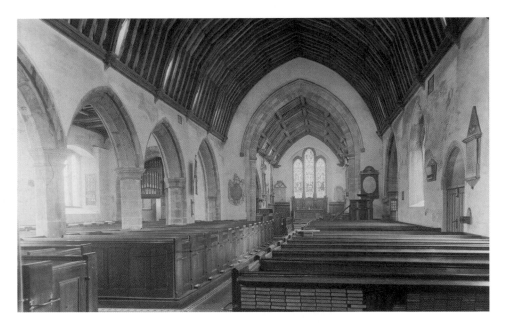

View of the nave and chancel, *c.* 1940. In medieval times there were no seats for the ordinary parishioners and the floor would have been covered with straw. Worshippers then had a choice of seven altars for prayer.

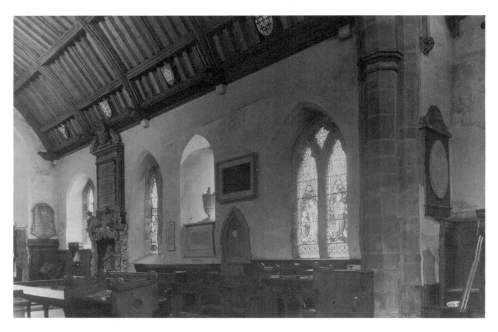

Part of the chancel showing the Greswolde Monument, *c.* 1950. The heraldic shields on the edges of the roof beams represent places connected with Yardley. They were presented in 1942 by the then vicar, Canon E.L. Cochrane to celebrate his forty years as a priest. Canon Cochrane was a keen local historian and left behind a photograph collection reflecting his interest.

three

The Yew Tree

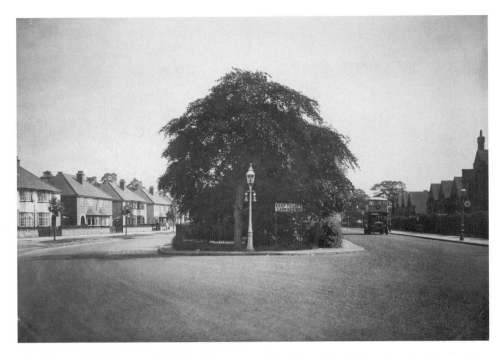

Church Road looking towards the Yew Tree, *c.* 1931. The Outer Circle No. 11 bus heading for the Swan was a new suburban service introduced in 1926.

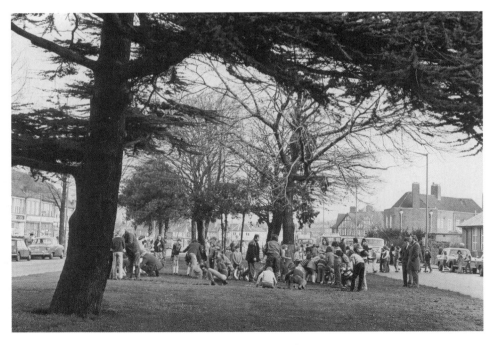

Children from Church Road School planting bulbs under the trees, 1974.

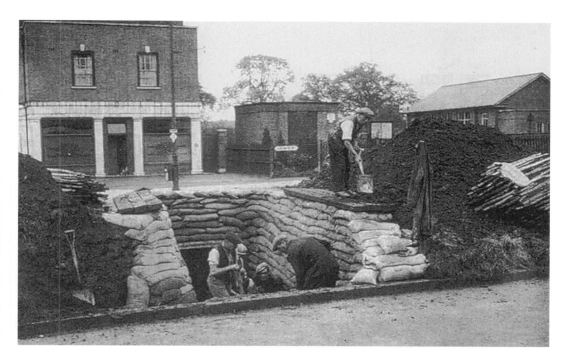

An air-raid shelter under construction outside the Municipal Bank in Church Road, *c.* 1940. A few yards up the road on the edge of the Oaklands Park was a camp of wooden huts used by an anti-aircraft battery unit.

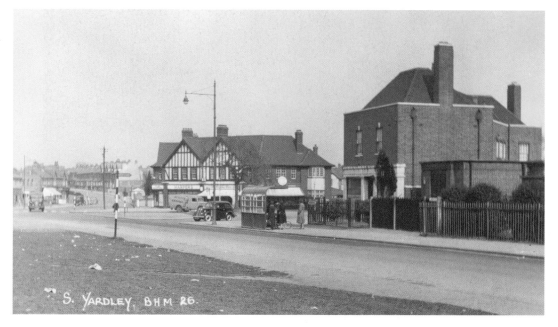

The site in 1957, with no sign of wartime activity, or the heavy traffic of today, and its accompanying traffic lights.

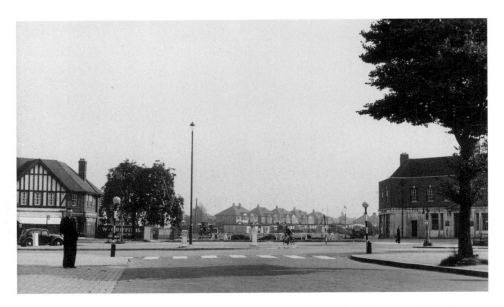

The Yew Tree junction from Hobmoor Road, 1953. Five roads meet here but most of the shops and houses date from the 1930s. The vacant land ahead was intended to be a continuation of Hobmoor Road to Rowlands Road but flats were built instead.

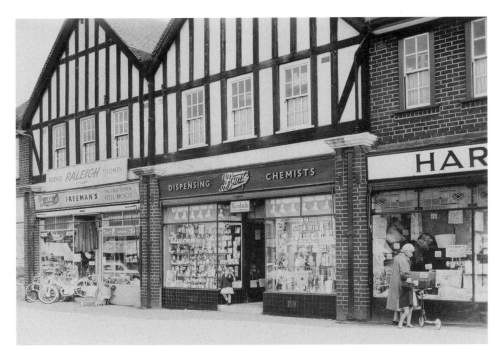

Church Road shops, 1963. Boots was here for half a century, and only recently moved to the new centre in Stoney Lane. Chemists' shop windows were fascinating then, full of strange sounding medications and glamorous new beauty products. Every local shopping centre had the essential cycle shop.

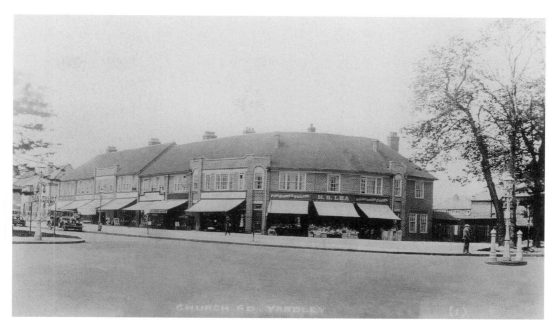

The new shopping parade on the corner of Church Road and Hobmoor Road, *c. 1930.*

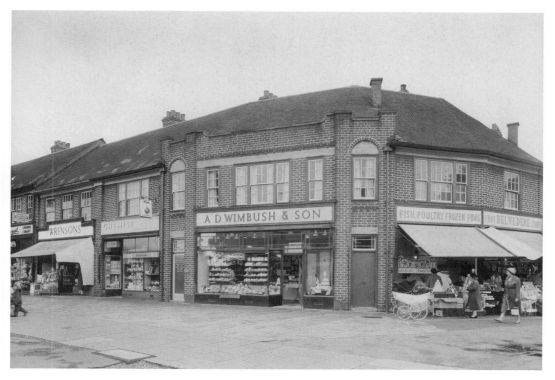

The same corner in 1960, with all the famous names in grocery shops to be found in every suburban shopping centre.

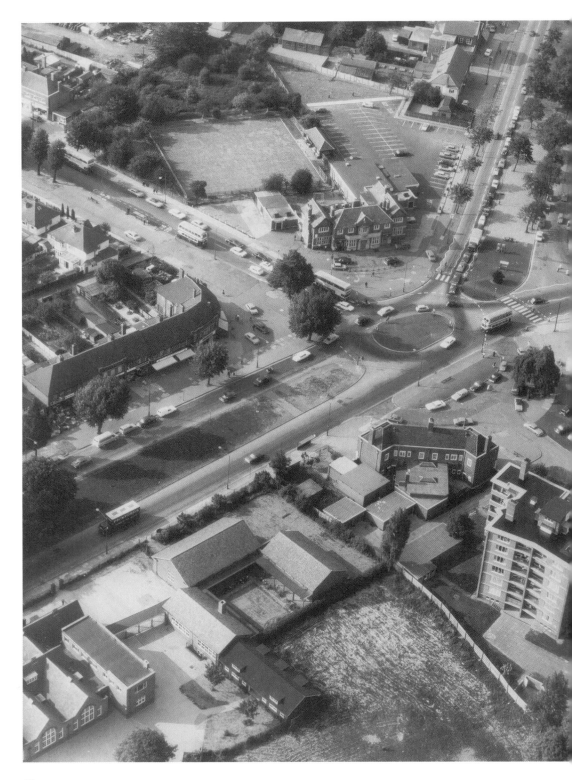

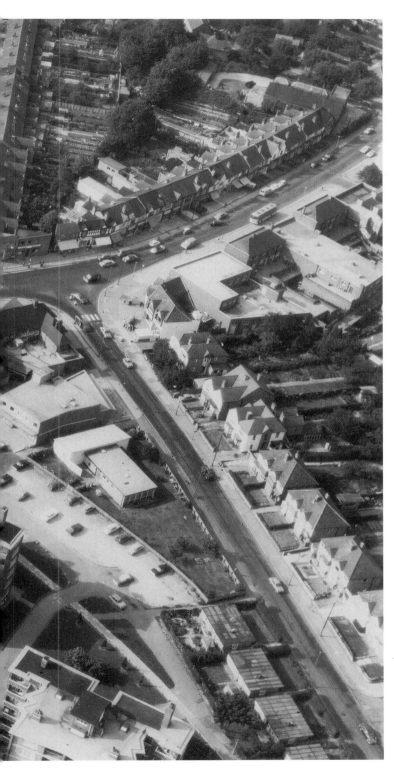

Aerial view of the Yew Tree
junction and shopping centre,
1970. The 'temporary' post-war
prefabs were still there in Yew
Tree Lane, on the site of Holly
Farm. There is a good view of
the well-used bowling green
behind the Yew Tree pub, both
now gone.

41

Looking up Smarts Hill, later called Barrows Lane, to where Croft Road was later laid out, *c.* 1910. The only dwelling here at this time was the Croft, on top of the hill, out of sight on the right.

Barrows Lane hill, *c.* 1950. In 1939, when the road was upgraded, the dual-carriageway island was built up to retain some of the fine old trees which were here then. Many of the houses have elements of the popular inter-war mock-Tudor timber and plaster style.

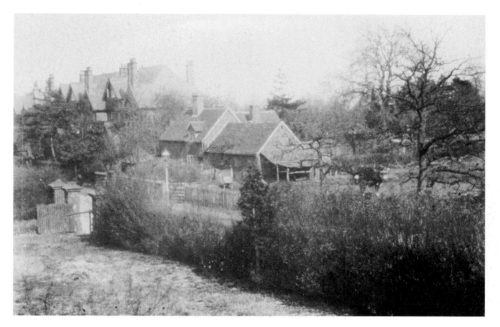

Adams' Farm in Church Road, *c.* 1925. Homecroft Road was later cut through the farm. The Edwardian houses still stand.

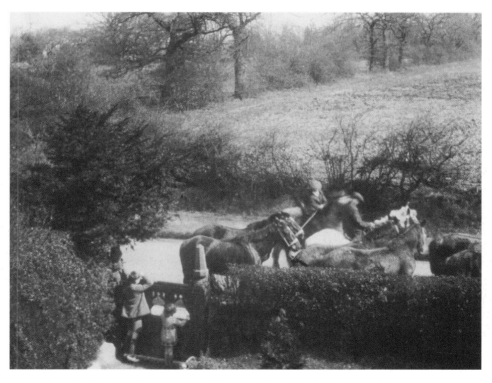

Horses from the farm heading up to the village, possibly to be shod at the smithy, *c.* 1925.

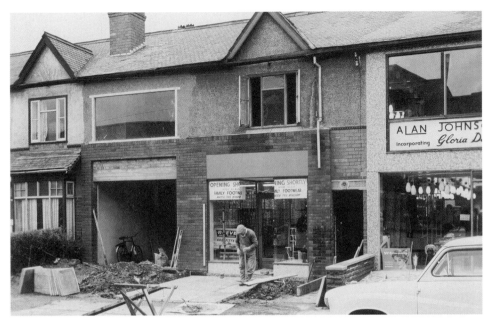

Church Road (Nos 181-187) in 1963. This row of small, late nineteenth-century terraced houses stretched to the corner of Stoney Lane, but in time, more and more were converted into family shops to meet local needs as the population grew.

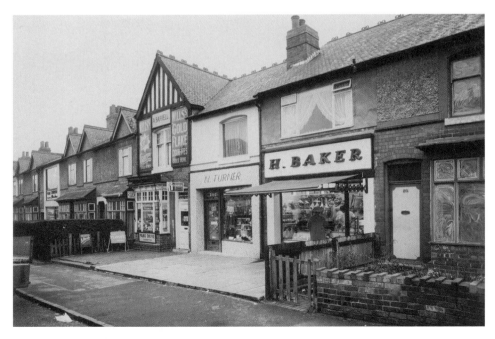

Church Road (Nos 187-201) in 1962. Small shops like these can easily change use with change of ownership, but Baker's is still a butcher's shop, called Bentleys. The house on the right, No. 201, was later converted into a fishmonger and greengrocer's, and is now a sandwich shop.

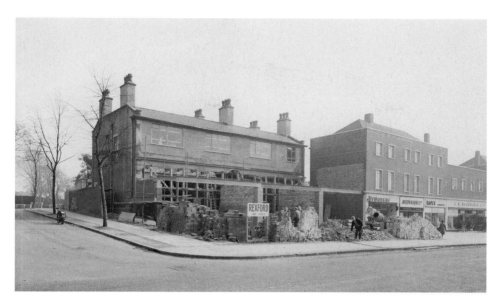

New shops in Church Road, on the corner with Croft Road, 1956. The old house, known as the Shrubbery or Shrubberies, dates from the early 1800s and has always been occupied by men of means. In 1841, it was Bartholomew Brotherton, who ran a cab company, and in 1891, it was Frederick Bird, a wine merchant from Gloucestershire. A small row of cottages attached to the Shrubbery housed coachmen and gardeners.

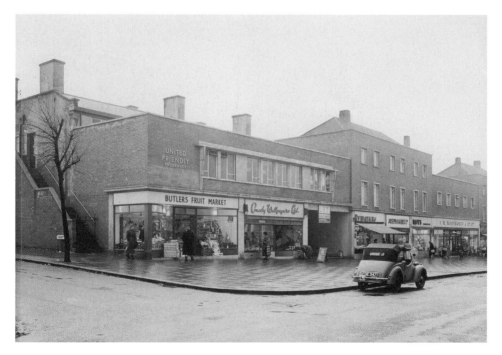

The same view a year later, with the Shrubbery retained behind a modern front. The wallpaper shop is now Rays' and Radio Rentals took up the vacant lot.

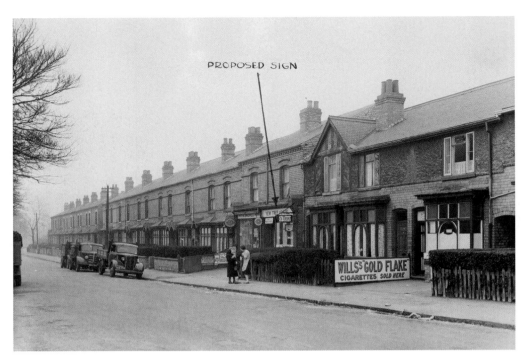

Stoney Lane, near the Yew Tree, in 1953. The terraced houses in Church Road continued round this corner, where some were also converted to shops. The lorries are parked outside a house serving as a café.

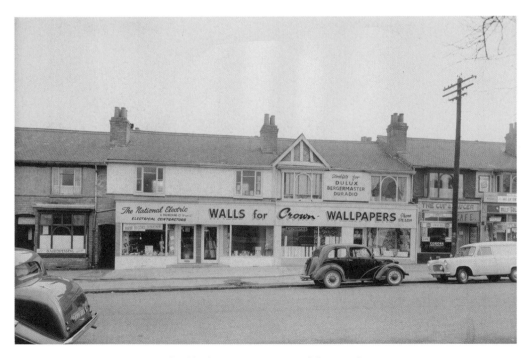

Stoney Lane (Nos. 6–18), 1961. This block is a continuation of the row above.

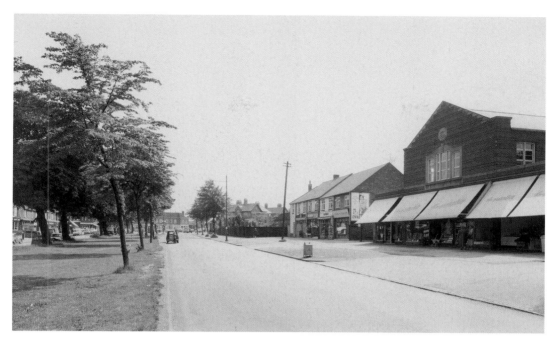

The Co-op store in Stoney Lane in 1963, facing the houses and shops shown opposite. The larger suburban Co-ops, like this one, had a hall above for members' social events and Guild meetings. It closed down in the 1970s but a new Co-op opened in 2002 on the site of the Yew Tree pub, a few yards away.

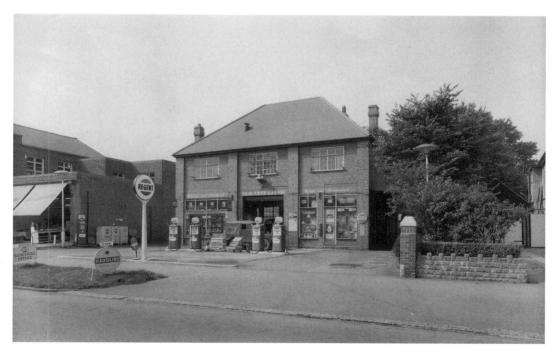

The Yew Tree garage in Stoney Lane – the latest in forecourt design in 1960.

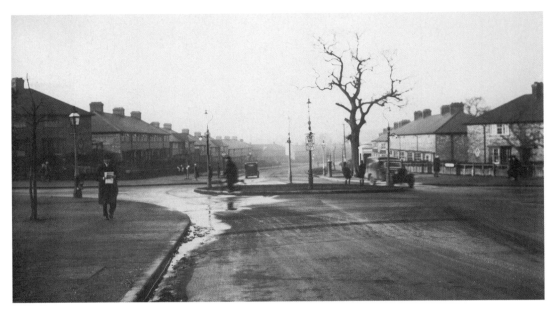

Hobmoor Road from the Yew Tree, 1933, showing the newly built municipal housing estate.

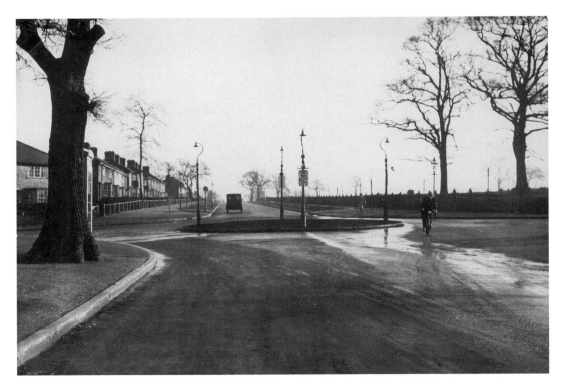

Looking back towards the Yew Tree. The open space on the right was then called the Oaklands and Redhill Recreation Ground. Prefabs were built along here after the war, with allotments behind. A new home for Hobmoor Road Primary School is currently being built on this corner of the Oaklands.

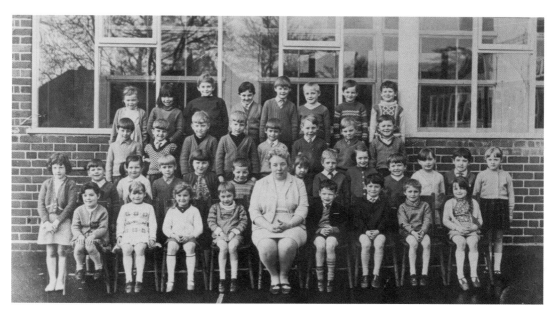

Mrs Humphreys' class of 1967, Hobmoor Road School.

The junction of Deakins Road and Holder Road, from Deakins Farm, 1924. This rural scene would soon disappear under municipal housing. Deakins Cottages were in Workhouse Lane and date from the early 1800s. The usual residents were farm labourers, gardeners, journeymen blacksmiths and millers.

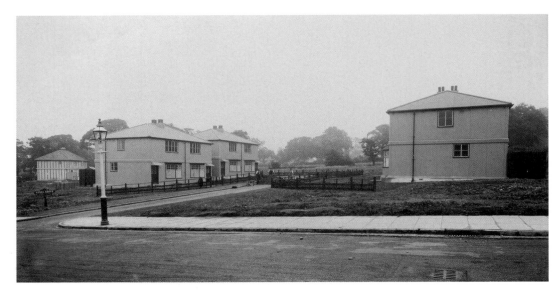

Steel Grove, Kathleen Road, *c.* 1935. The estate built between the wars from Hobmoor Lane to Hay Mills was vast, and different construction methods were tried. Steel Grove took its name from the steel-frame construction tried here. The encroachment of housing onto what had been good farming land and a popular rural escape is quite clear, but huge numbers of new houses were needed to rehouse people from the overcrowded and unhealthy central areas of the city.

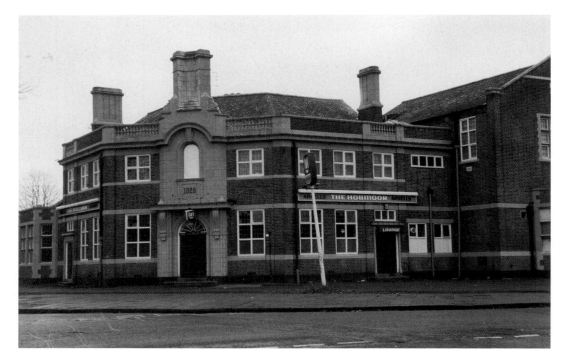

The Hobmoor pub, on the corner of Millhouse Road, 1985. It was built in 1928 as a facility for the new estate, but was demolished not long after this photograph was taken.

four

Green Spaces

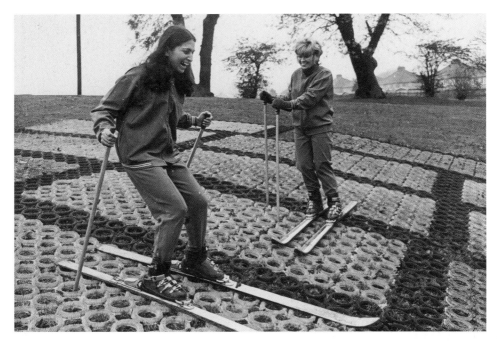

The dry ski run, Gilbertstone Recreation Ground, 1971. This large open ground between the Coventry Road and Moat Lane slopes sharply on the Moat Lane side, enough to be suitable for this short-lived sporting experiment.

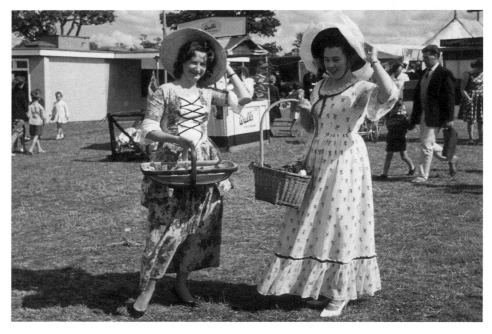

Dressing up 'country style' for the Fayre, June 1963. Events with an agricultural theme have always been popular with Birmingham people.

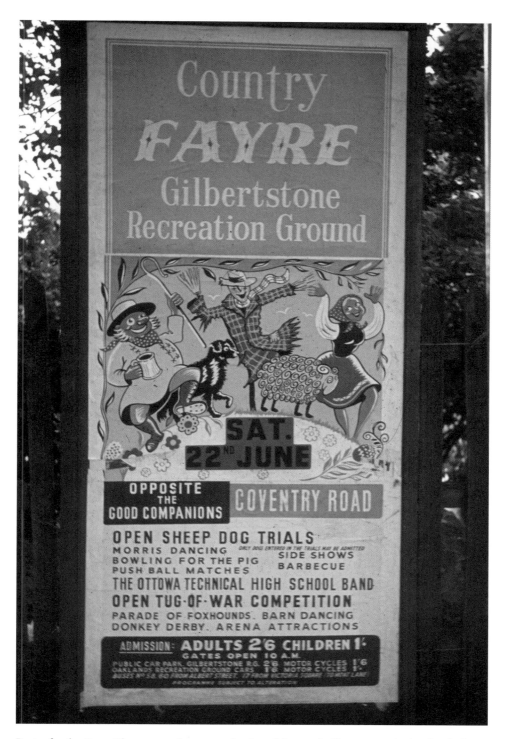

Poster for the Fayre. These sorts of events took a lot of time and effort to organise by the city's Parks Department and are rare today.

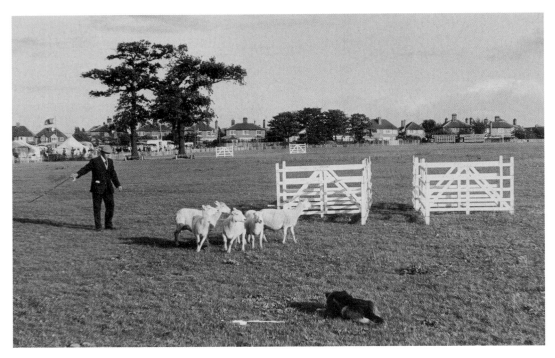

Sheepdog trials at the Fayre. Over 100 dogs from all over the country competed for the City of Birmingham Challenge Trophy.

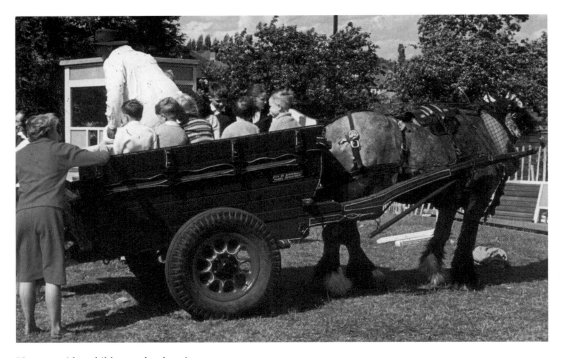

Hay-cart rides, children only please!

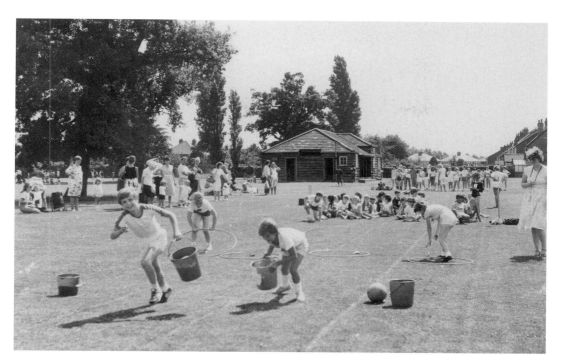

Church Road Junior School sports day at the Oaklands Recreation Ground, July 1986. Most of the events were pure fun, including sack races, the three-legged race and the egg and spoon.

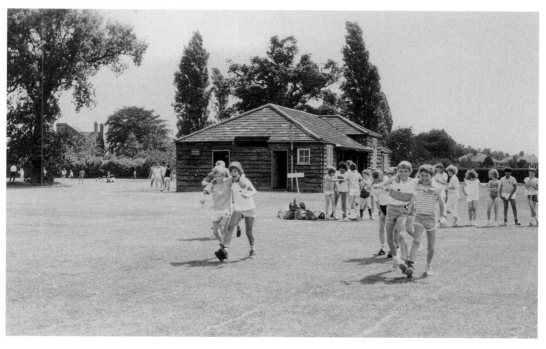

It is sad that so few schools now have the time for such days.

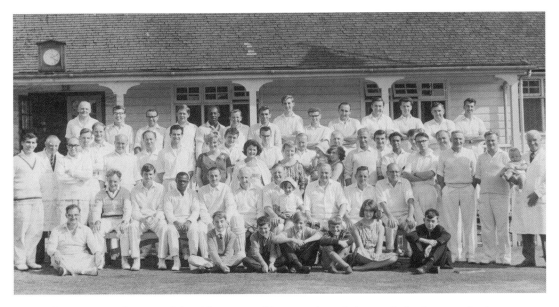

Birmingham Municipal Sports Club cricket team, with supporting relatives, 1964. In the 1930s, land was bought in Sedgemere Road from Yardley Great Trust, for a sports ground for city council employees, following the practice of large companies like BSA and Cadbury's.

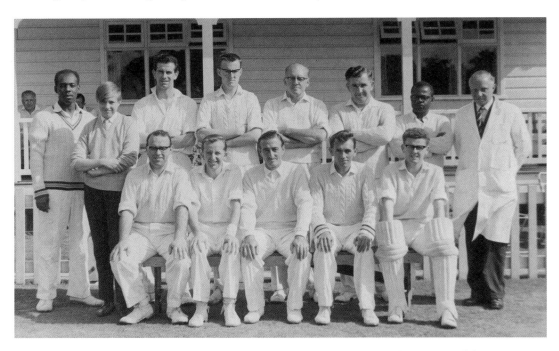

The First Eleven team, 1964. Football, hockey and archery were also played at Sedgemere Road, but cricket was the most popular game. The players are, back row, from left to right: G. Miller, M. Smith (scorer), B. Cox, D. Hornsby, S. Eyres, D. Jones, L. Anderson, T. Rembges (umpire), and front row: B. Cook, W. Parry, E. Sutcliffe (captain), A. Osborne, R. Rowley.

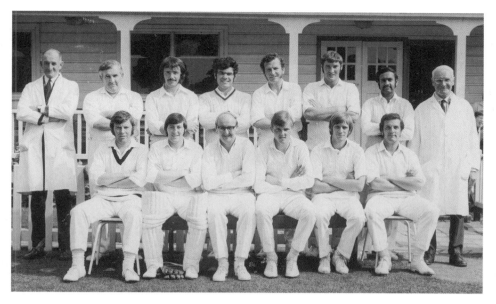

The First Eleven team, 1971. The players are, back row, from left to right:, J. Cocks (umpire), D. Jones, G. Clarke, D. Woodhead, P. Cooper, M. Browne, C. Nand-lal, R. Burns (umpire), and front row: C. Reynard, A. Outram, B. Hodder (captain), R. Spence, B. Jones, J. Carr. As the council shed large numbers of staff from the 1980s, the sports ground was no longer viable. As the land had been covenanted for leisure use only, it was eventually sold on as a private club.

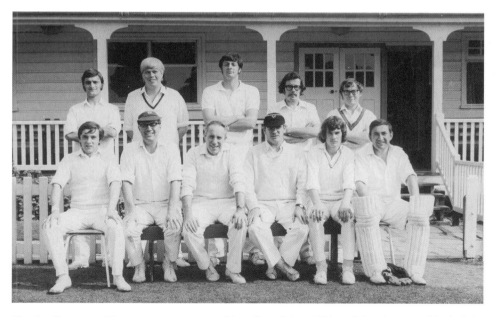

The Strollers, 1971. The team names presumably reflected the abilities of the players, and included the First and Second Eleven, a Sunday Eleven, and the Ramblers and the Strollers. These players are, back row, left to right: D. Foster, K. Oliver, R. Chapman, D. Surtees, F. Cork, and front row: D. Staley, J. Purnell, D. Hollier (captain), J. Clarkson, G. Rees, M. Harrison.

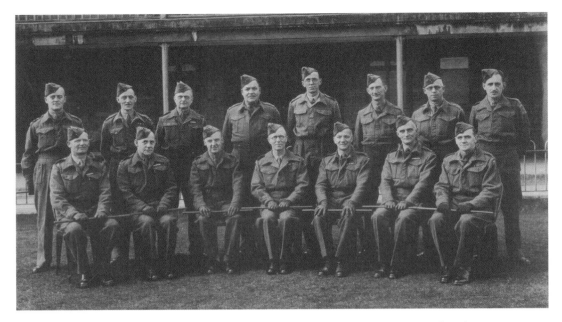

Officers of 'D' Company, 40th Warwickshire (Birmingham) Battalion of the Home Guard, at the Birmingham Co-operative Society's sports ground, Barrows Lane, 1944. They are, back row, left to right: Lts H. Stephenson, H. Packer, A. Winn, W. Price, W. Smith, A. Moore, E. Parry, H. Heath, and front row: Lts J. Masters, W. Young, Captain A. Phelps, Major E. Turner, Lts W. Cutler, W. Mansfield, W. Hulls.

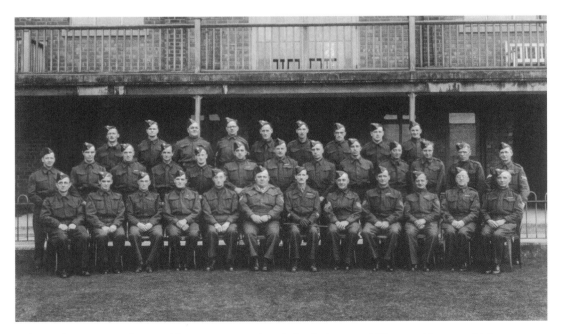

Other ranks, names not known. Almost every man here is bordering on middle age, either too old for the forces, or in protected jobs. They would all have been working full-time, and turning out for Home Guard duties outside work hours.

Casual parade by the tennis courts, *c.* 1942. Many sports grounds and parks were at least partly turned over to allotments and various military uses during the Second World War, including training, barrage balloon and anti-aircraft placements, and POW camps. The Sedgemere Road ground had barrage balloons.

Time for a cigarette and a chat. From January 1943, there was also an air-raid wardens' post at Barrows Lane, in the dressing room of the sports pavilion.

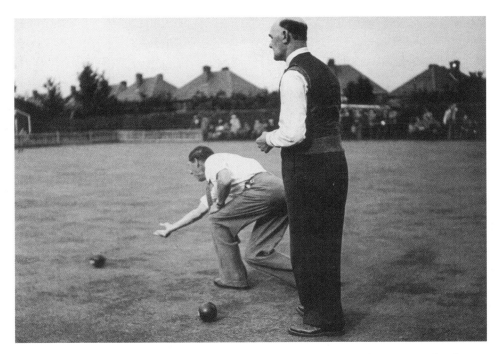

Bowling at the Co-op ground, *c.* 1950. Other sports included football, cricket, tennis and archery.

The umpire's decision is final! The players' dress may seem casual when compared to teams today, but they were just as serious about the game.

Unidentified football players, *c.* 1975. As well as the individual Co-op departments having their own sports days here, there were also inter-department tournaments.

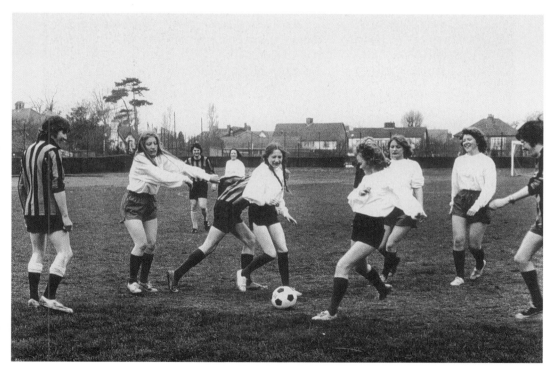

Unknown liberated Co-op ladies playing a men's team at football, *c.* 1975.

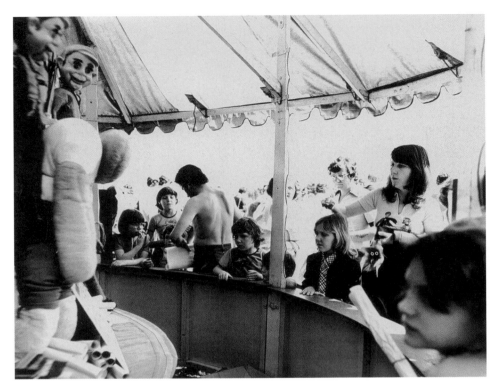

Sports day, *c*. 1975. The annual fun day for staff and their families included sideshows, Punch and Judy, apple bobbing and tug-of-war – something to appeal to everyone.

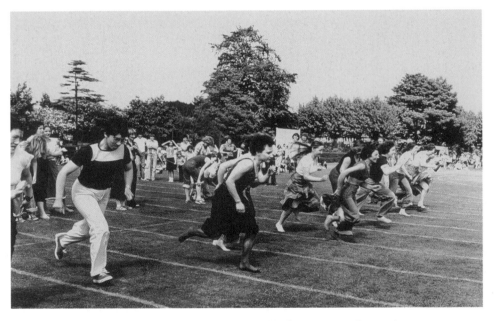

A ladies' sprint, most of them having removed unsuitable footwear in order to win.

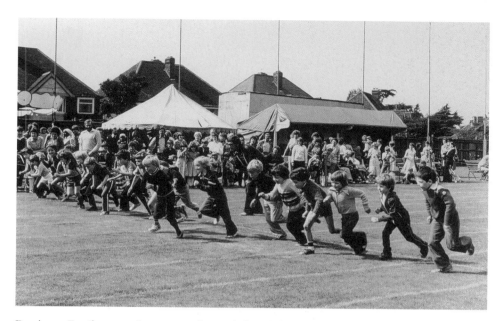

Boys' race. Family sports days were well attended, with hundreds present. The Co-op traditionally valued and promoted after-hours education and leisure activities for its employees, believing this helped to make them good citizens.

The egg and spoon race was not as easy as it looked.

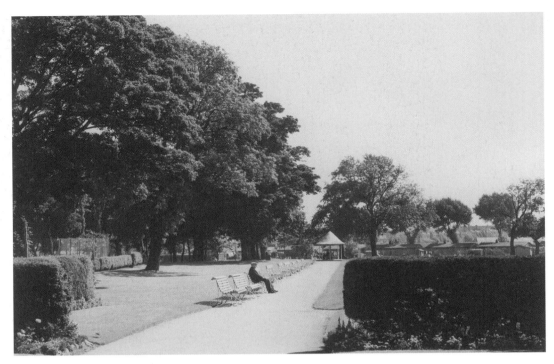

A quiet corner of Yardley Old Park, with a view of the prefabs on the Queens Road side, 1966.

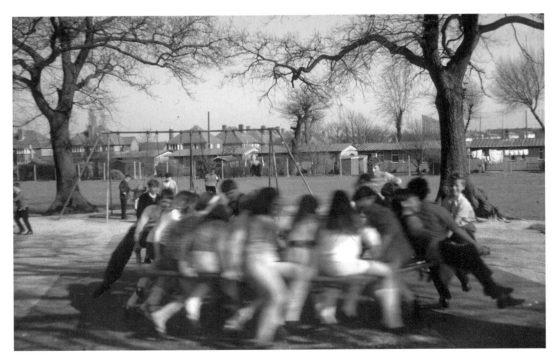

Overloading the Spider – a Health and Safety expert's nightmare, *c.* 1965.

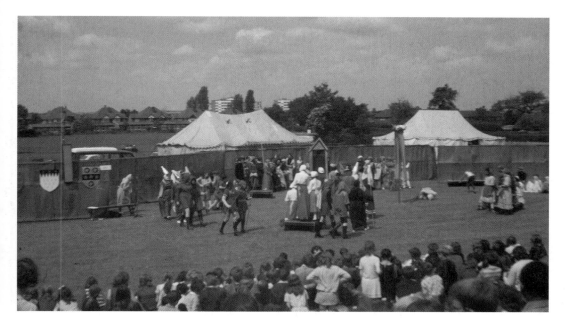

In 1972, Yardley celebrated its 1,000 years of history. Events were held all over the parish from 19 April to 16 June, and included concerts at churches, jousting at Fox Hollies Park, agricultural and historic transport rallies at Sarehole Mill, and canal trips. On 3 July a pageant of Yardley's history was performed by 450 schoolchildren at the Old Park.

Another quiet corner away from the footballers, on the north side of the church, *c.* 1965.

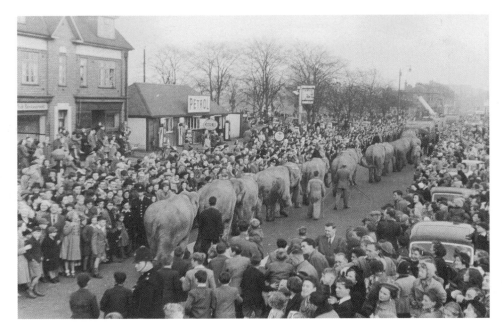

Elephants from Bertram Mills Circus heading for Heybarns Recreation Ground at the River Cole, c. 1955. This was a traditional stopping place for circuses in the 1940s and '50s, before circuses with animals became politically incorrect.

A baleen whale on display at Heybarns Recreation Ground, June 1970. It was probably a stuffed exhibit or a model, part of the menagerie which accompanied most circuses. Baleens are toothless whales which feed by straining plankton from sea water. In the past, their bones were prized for whalebone corsets.

five

The Swan

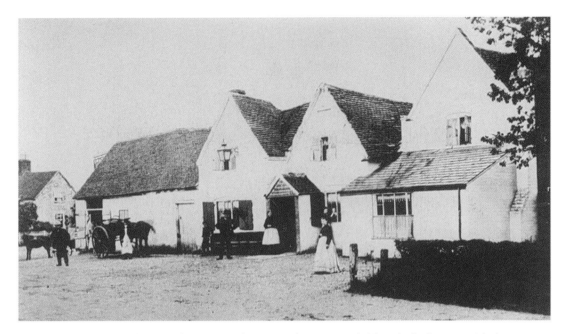

The Swan Inn, *c.* 1870. There had been an inn here since the 1600s, and although the last one with that name has now gone, the area is still known widely as 'the Swan'.

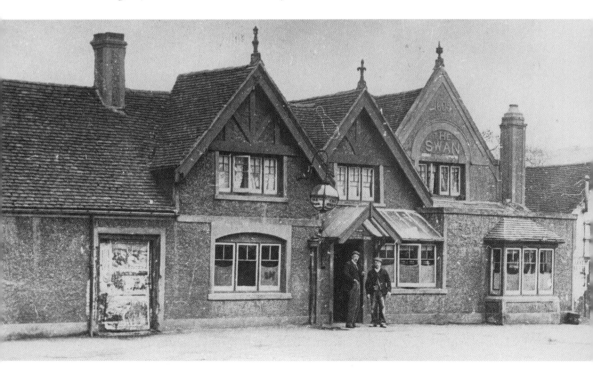

The old building above was modernised and is shown here in around 1890. The Swan in all its forms has to top the list as one of the most photographed pubs in Birmingham.

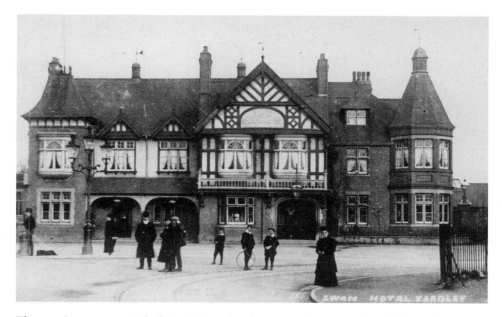

The new Swan, *c.* 1905. Rebuilt in 1898 as a hotel, it was at the centre of a rapidly growing suburb. From 1907 trams ran from here into the city, allowing local people to travel to work. These well-dressed adults are waiting for the next one.

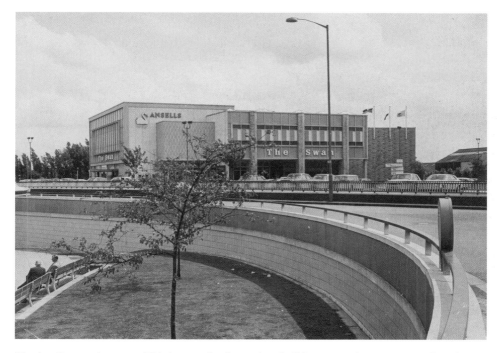

The last Swan pub, *c.* 1980. This large and ugly modern building opened in 1967, to replace the Victorian Swan demolished to make room for the Coventry Road underpass. Part of it was Blakesley House, offices for Ansells Brewery.

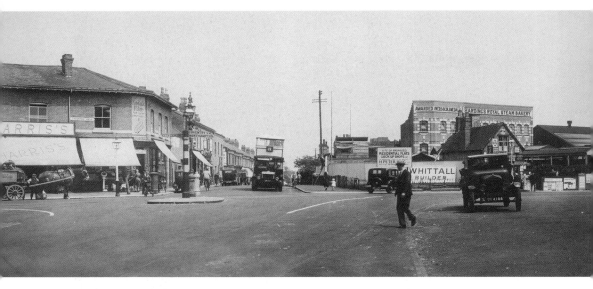

Church Road from the Swan junction, 1934. William Painter's funeral business, which featured in Mike Byrne's book on Yardley, stood on the vacant plot until he moved to new premises in Yardley Road in 1926. Harding's bakery survived until the 1960s.

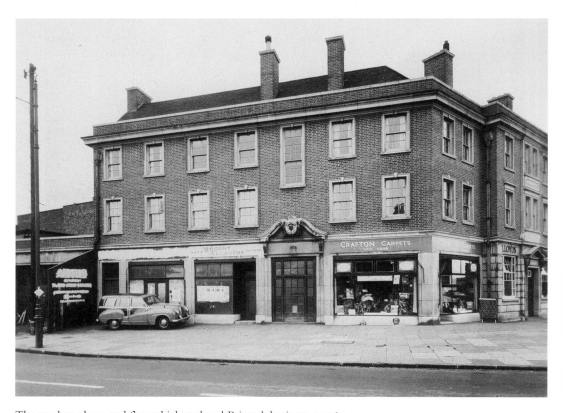

The modern shops and flats which replaced Painter's business, c. 1960.

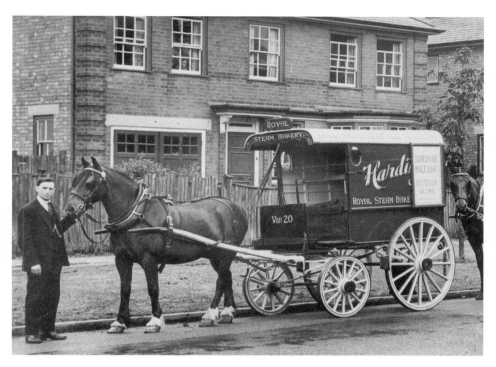

Harding's delivery cart, 1925. The business was started by George Harding in the 1890s in a shop in Monument Road. Ernest Harding built the bakery in Yardley, and had several shops in the area.

Harding's bakery – the Church Road entrance, 1951.

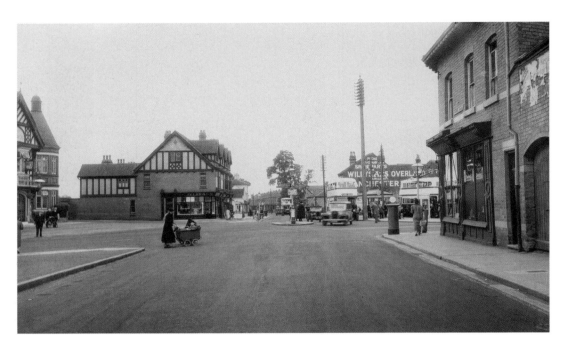

Yardley Road from the junction, *c.* 1935.

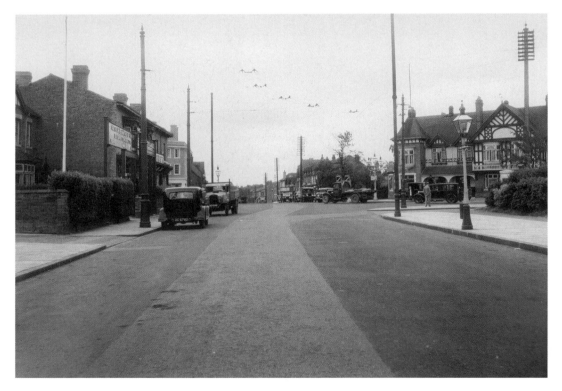

Looking south along the Coventry Road towards Gilbertstone, *c.* 1935.

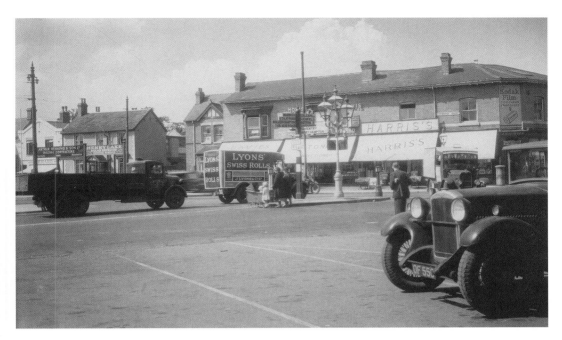

The north side of the Coventry Road, looking towards the city, *c.* 1935.

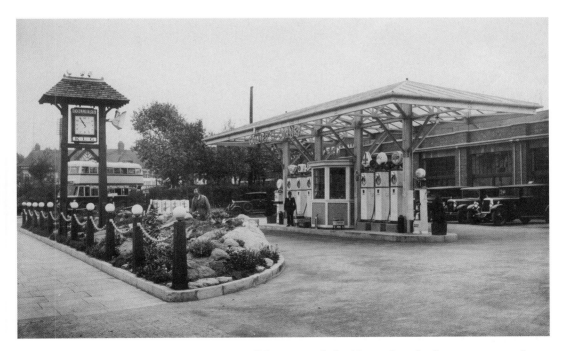

Colliers' Corner at the Swan, 1934. This well-known car dealership was here for forty years, occupying the old tram depot. The road widening in the 1980s badly affected many of the old local businesses and Collier's moved elsewhere. A DIY store used the building for a time, and until recently, an office supplier's premises were to be found here.

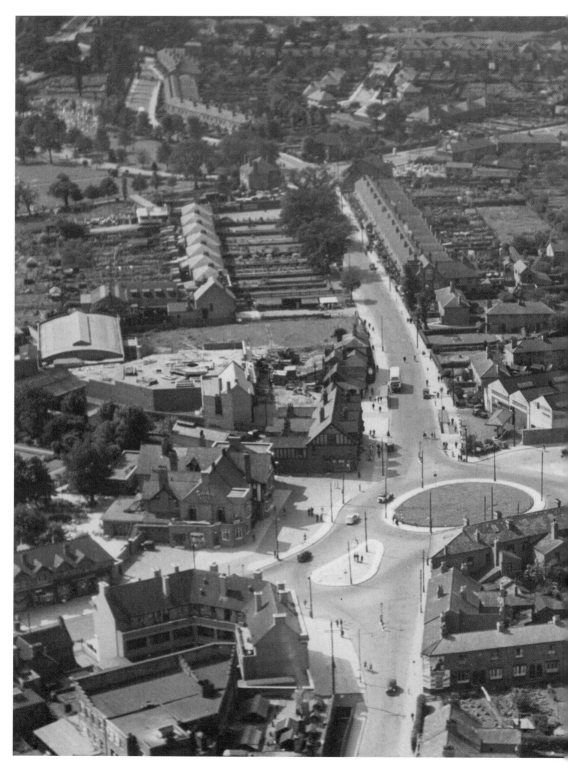

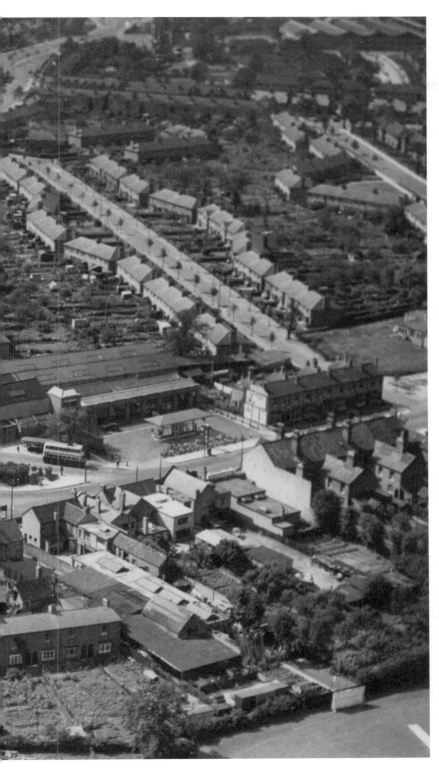

Aerial view of the junction from Church Road, 1938. At the centre left, the new public library is under construction. At the top right are the municipal housing estates built from the 1920s. The lack of road traffic is incredible compared to today.

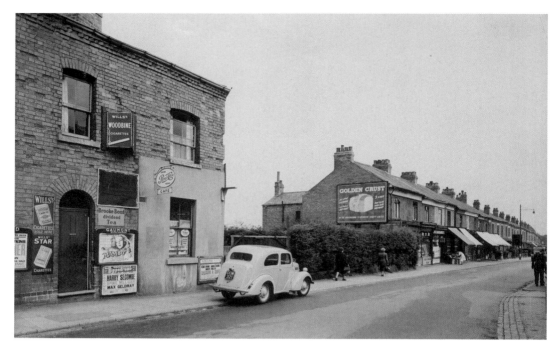

Church Road looking towards the Yew Tree, 1955, showing the corner shops still commonly found all over the city at that time. Four different brands of cigarette are advertised.

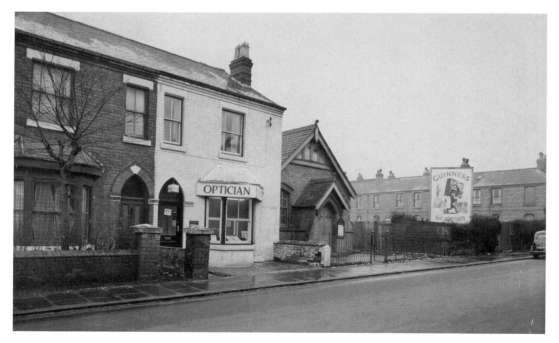

Church Road at the Swan, 1955. These buildings and terraced houses were later demolished to make way for the Swan indoor market.

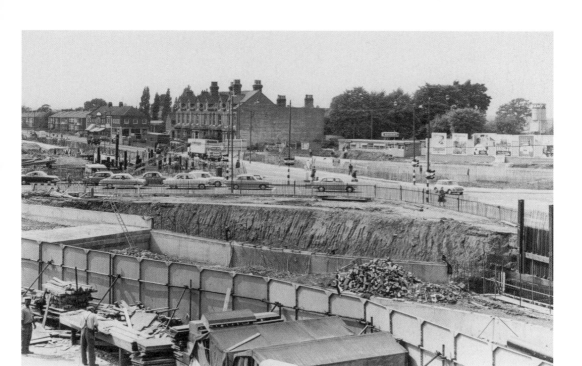

The Swan underpass under construction, *c.* 1965.

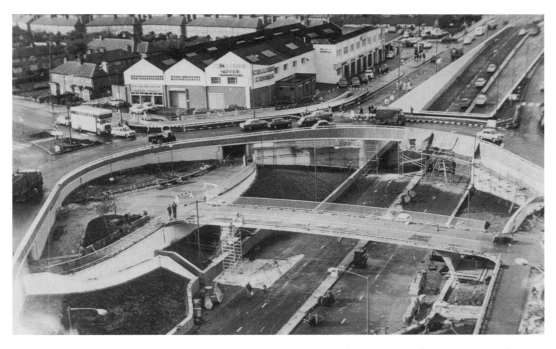

The problem of accommodating the busy Outer Circle route where it crosses the Coventry Road was solved by adding an underpass for the A45 and a raised roundabout for the Outer Circle.

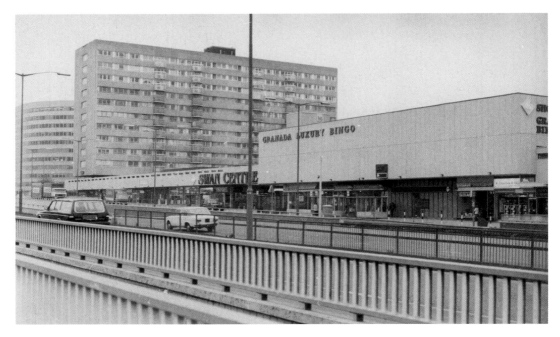

The development which replaced the Tivoli cinema and the old shops on the corner of the Coventry Road and Church Road, *c.* 1986. Built in 1962–67, it was designed by James Roberts, architect of the Rotunda.

Reopening celebrations for the centre in 1986, after a fire: with 166 stalls, 3 banks, a post office and 24 shops, it was supposed to generate 400 jobs for local people.

The outdoor market. Many of the older generation preferred shopping in small shops but inevitably, as more big supermarkets opened locally, customers for the centre declined.

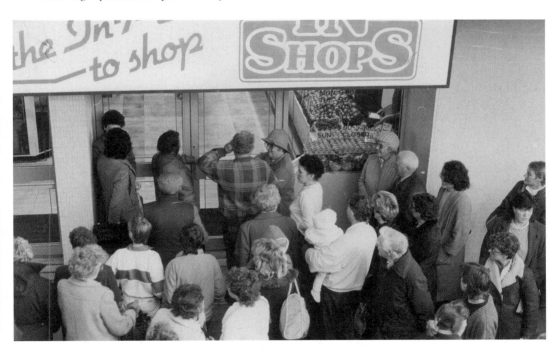

The 'In-Shops' organisation, which ran the market from 1986, had similar retail outlets at Perry Barr, Kings Heath and Erdington. The market and many of the shops are now closed, as a large supermarket development has been agreed and will hopefully regenerate the area.

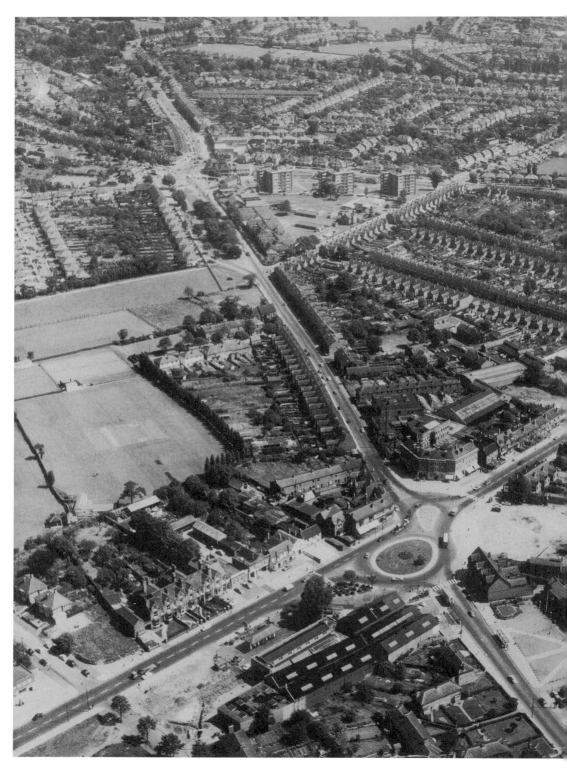

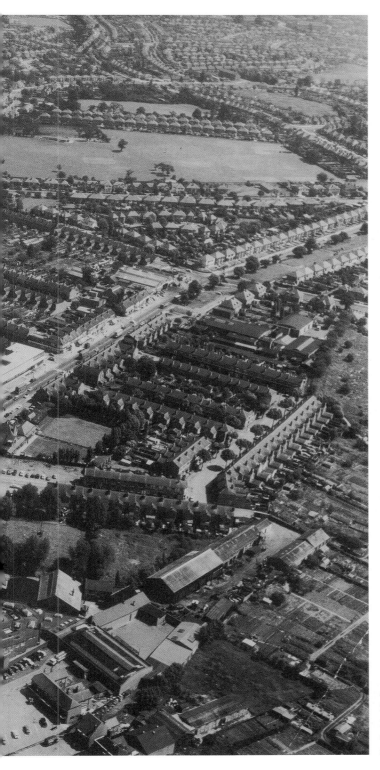

An aerial view of the junction
from the Broadyates estate in
1963: the Victorian Swan has been
demolished and work has started on
the new Tivoli centre.

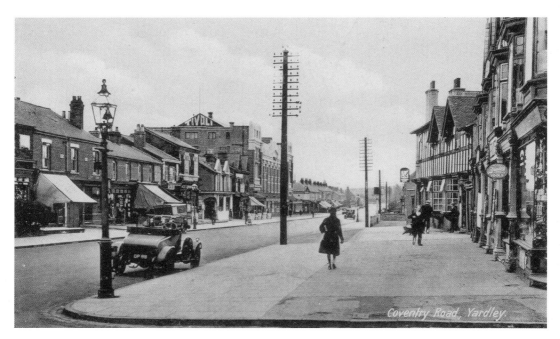

The Coventry Road towards Gilbertstone in around 1930, with the Tivoli cinema on the left and the old New Inn on the right.

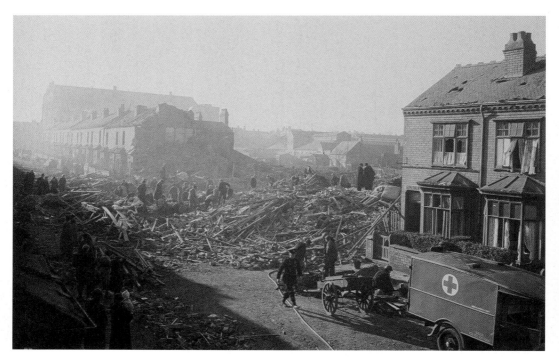

Lily Road, near the Tivoli, was severely bomb-damaged on the 14 November 1940. Eleven people from Nos 41, 43, 47, 49 and 53 were killed.

Gilbertstone

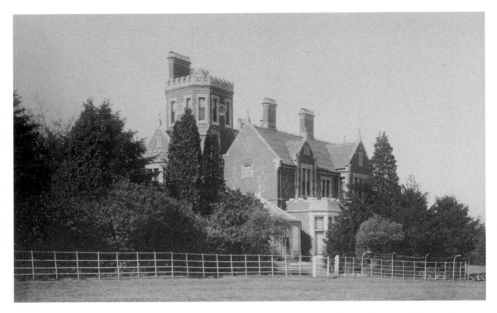

Gilbertstone, 1900. Built in 1866-67 for Samuel Thornley, a paint and varnish manufacturer, it replaced a much earlier house on the site. It was later owned by Richard Tangye, head of the firm which made hydraulic machines, pumps and steam engines. Tangye's supplied the hydraulic lifts which raised Cleopatra's Needle on the Thames embankment.

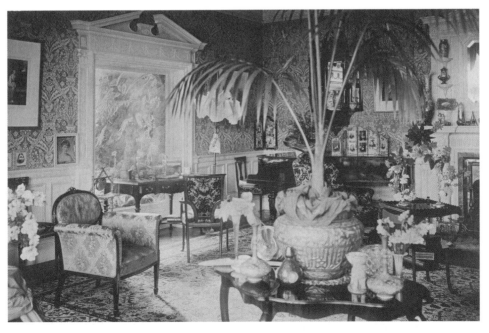

A drawing room in 1900, fashionably decorated and furnished, and full of fine china and glass, mirrors and photographs. The owner at this time was George Hookham, retired engineer, JP and self-taught expert on Shakespeare. He was also infamous for writing dozens of letters a week to local newspapers.

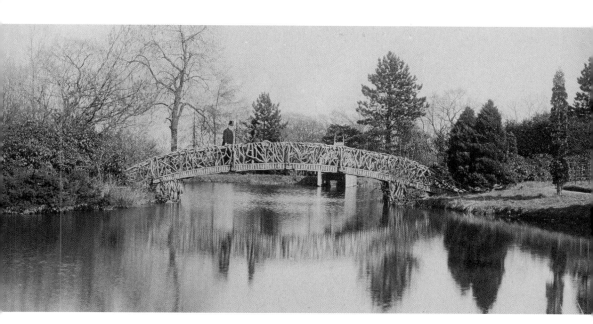

Pool with rustic bridge in the grounds at Gilbertstone, 1900. The top-hatted gentleman is
Sir John Benjamin Stone, an important local photographer, businessman, MP and former mayor of
Sutton Coldfield. These four photographs are from his own collection, bequeathed to Birmingham
Reference Library on his death.

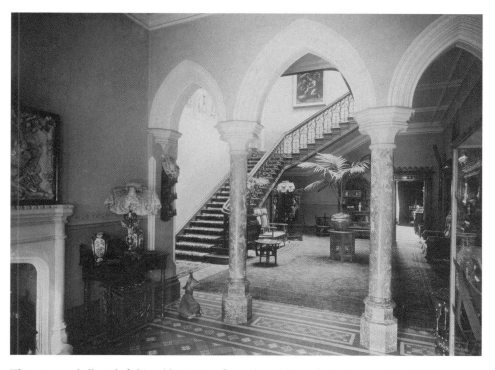

The entrance hall, with fashionable Minton floor tiles, and popular Indian occasional tables.

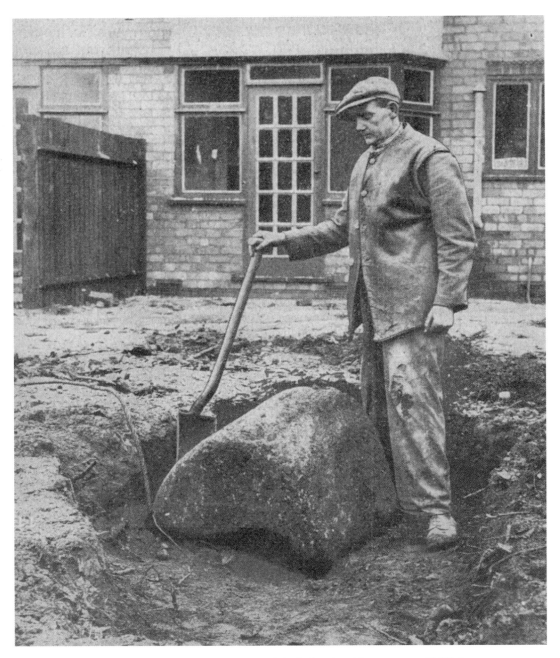

Rescuing the Gilbertstone, 1937. The house was demolished after the old estate was sold. Work on a new housing estate built in the grounds was well under way when the old boundary stone was found in the back garden of a house in Herondale Road. This glacial-drift boulder from Wales was first recorded in 1609 marking the boundary between Worcestershire and Warwickshire at Yardley. Canon Cochrane campaigned to retain it and it was first put behind railings on the corner of Sunnymead Road, where many older residents remember seeing it. In 1952 it was removed to Lyndon Green School, and is currently in the garden of Blakesley Hall.

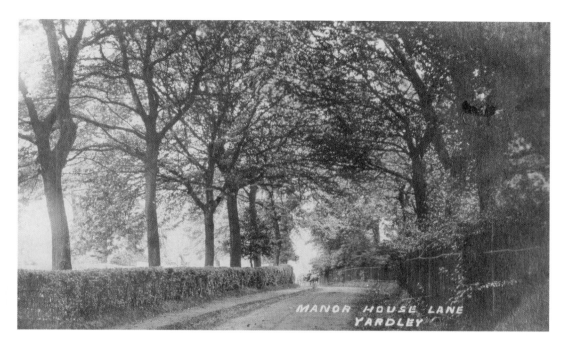

Manor House Lane, *c.* 1930.

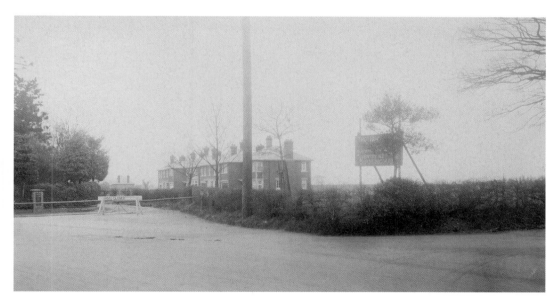

Newly finished houses in Rowlands Road, waiting for pavements and street furniture, in 1924.

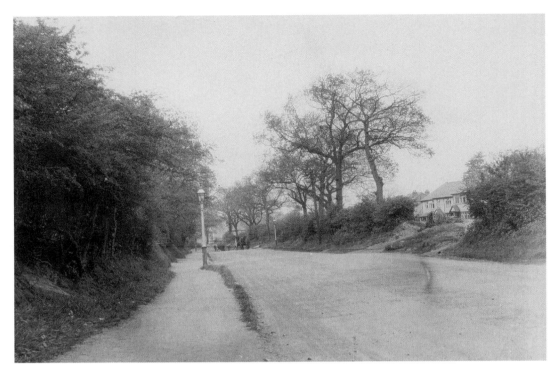

Clay Lane, looking towards the Coventry Road, with the cemetery on the left, *c.* 1930.

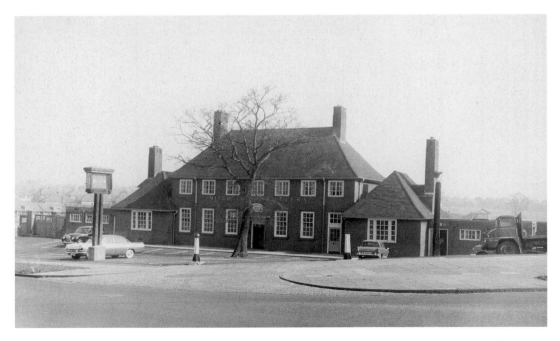

The Journey's End, Clay Lane, 1961. Opened in 1948, it is said that the brewery mischievously chose this name because of the cemetery across the road.

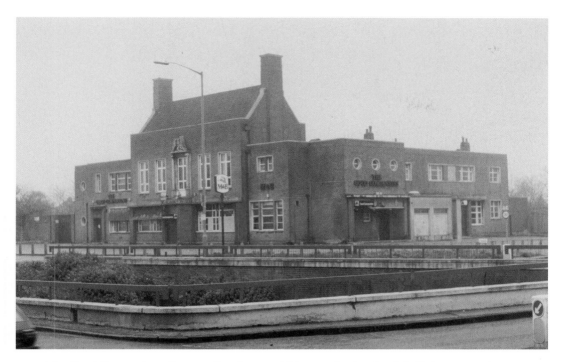

The Good Companions, Coventry Road, *c.* 1986. This was a landmark pub built in 1938 on the new Gilbertstone estate, and was demolished in 1993.

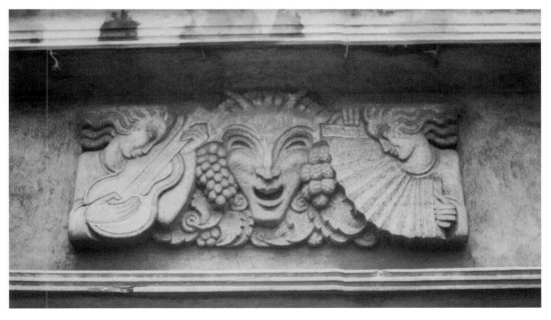

A laughing Pan with musicians, hops and grapes, found over the side entrance of the Good Companions, *c.* 1986. This was one of several carved decorations by William Bloye, a well-known local sculptor who had his workshop in Small Heath. Many buildings in Birmingham are decorated with his work.

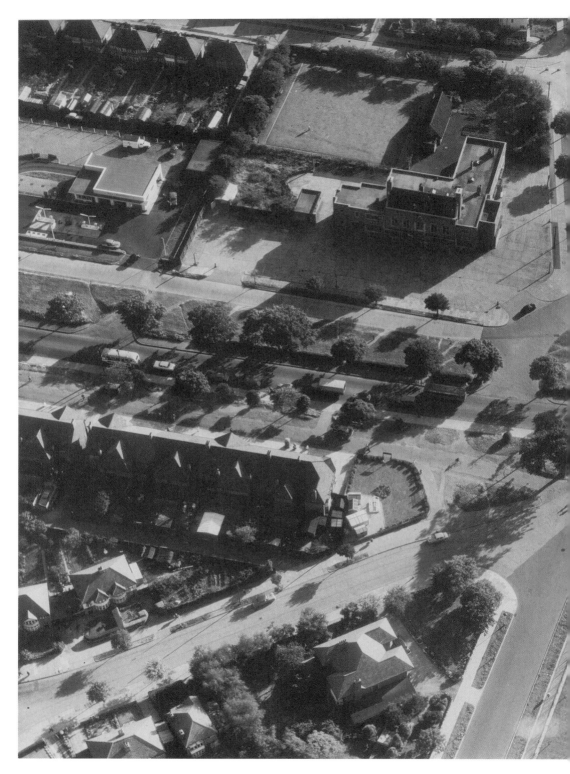

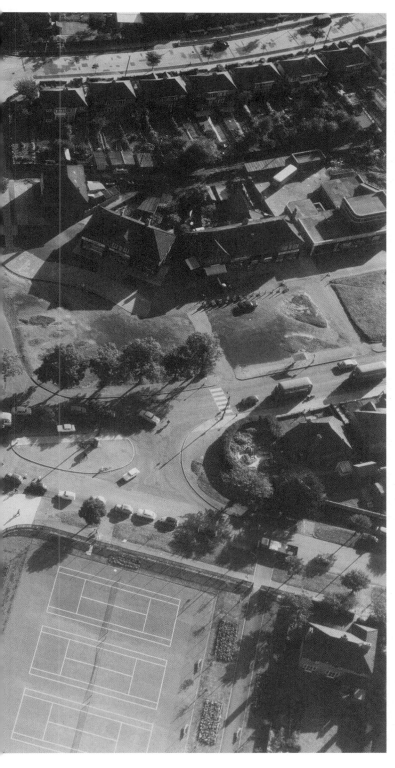

Aerial view of the Coventry
Road at Manor House Lane,
1963, from the south. The
road was later widened and an
unlovely and unloved underpass
built for pedestrians.

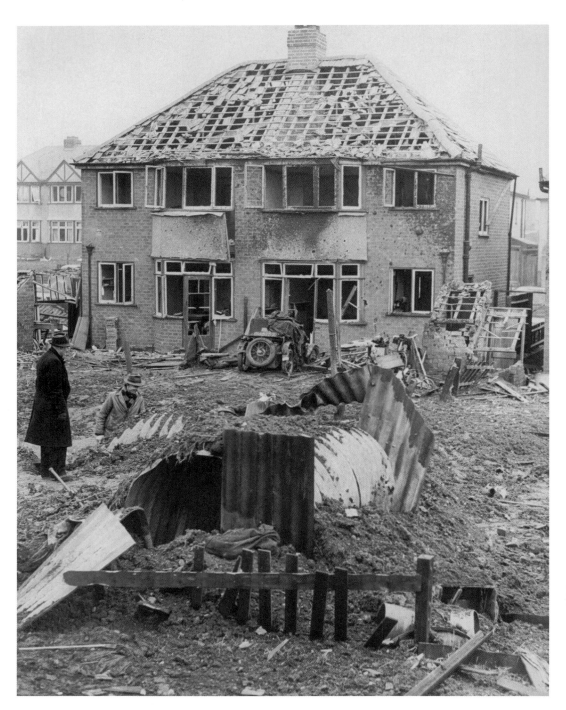

Bomb-damaged houses in Steyning Road, *c.* 1940. Luckily no one was at home when the air-raid shelter received a direct hit. Living in the suburbs was thought to be safer than living in the central districts of Birmingham, but this area was near the flight path of bomber aircraft from mainland Europe, on their way to Small Heath, Sparkbrook and Tyseley where many important war production factories were located.

seven

South Yardley

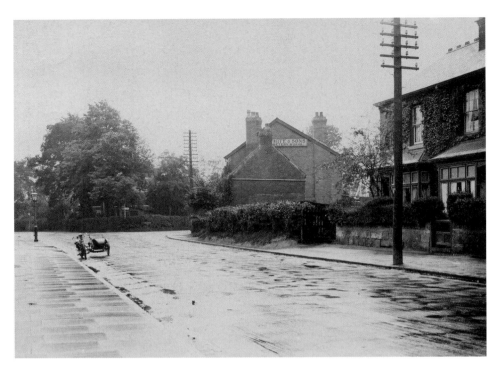

Yardley Road from the Swan, with Stockfield Road on the right, 1924.

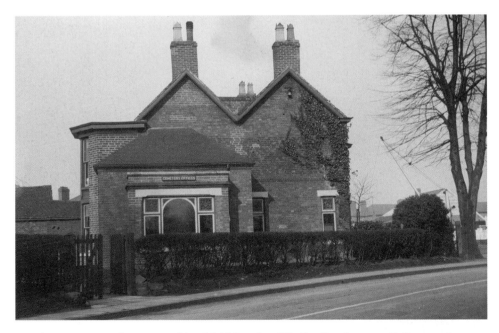

Broadyates House at the corner of Stockfield Road and Yardley Road, c. 1930. Built as a private residence in the nineteenth century, in recent years it has been offices for the cemetery and a neighbourhood office, and was recently demolished.

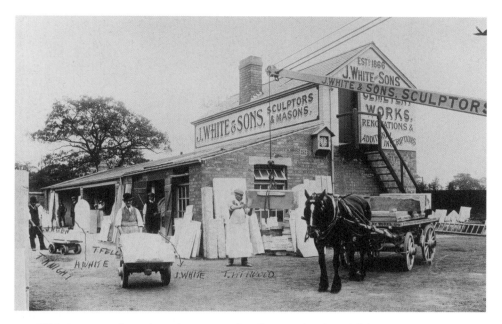

White's stoneworks yard, on the corner of Yardley Road and Stockfield Road, handy for the cemetery, *c.* 1910. This family business was started in 1866 by John White, shown standing behind T. Fell, with the barrow. At the crane is T. Atwood, and on the far left are T. Knight, J. Keen and H. White. The business now operates as Yardley Memorials.

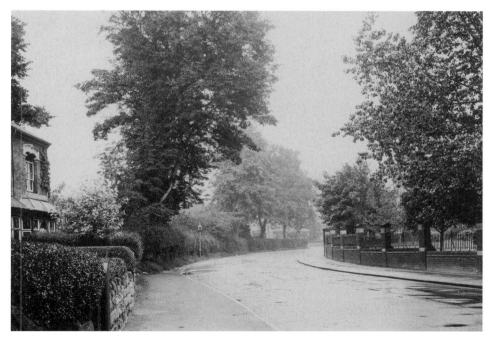

In Yardley Road, looking back to Broadyates House, 1924. This is now a busy part of the Outer Circle traffic route.

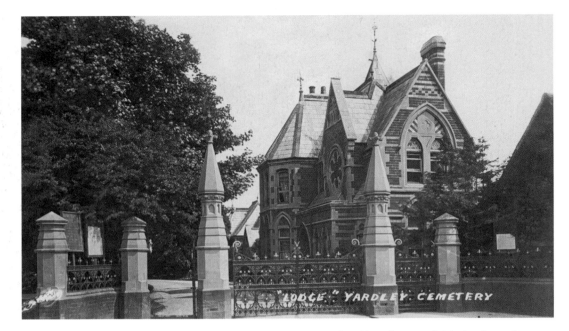

The original cemetery office in Yardley Road, *c.* 1910. Opened by the old Yardley Rural District Council in 1883, the cemetery then covered only 8 acres, and now extends to 64 acres. When Yardley came into Birmingham in 1911, Yardley residents were allowed to pay lower burial fees as a sweetener for the loss of their independence.

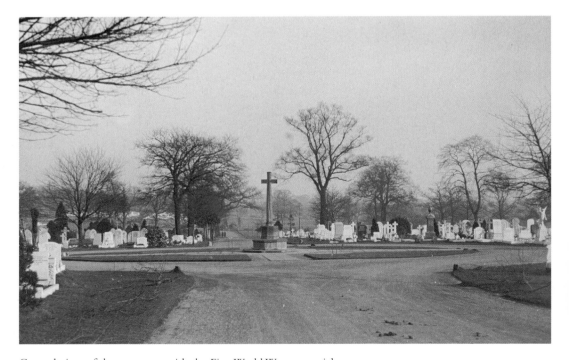

General view of the cemetery, with the First World War memorial cross, *c.* 1930.

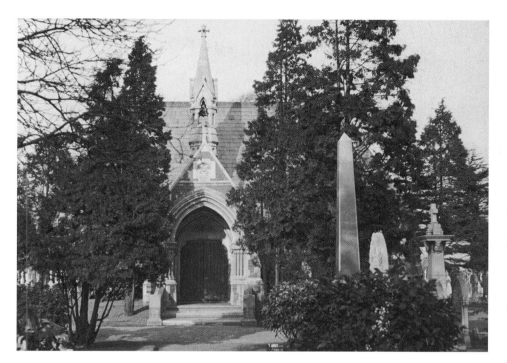

The original chapel, *c.* 1930. It was built at the same time as the office, in the popular Gothic style of the late nineteenth century.

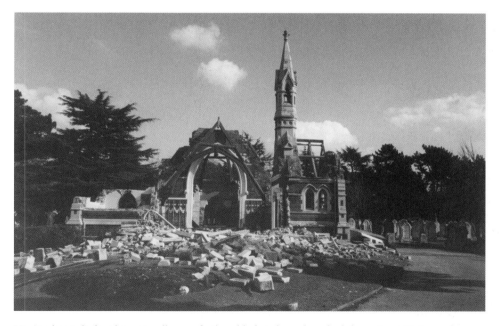

Having been declared structurally unsafe, the old chapel was knocked down in 1986. A much larger chapel had been built in 1934, but many older people continued to prefer the traditional style and comfortingly small scale of the old one.

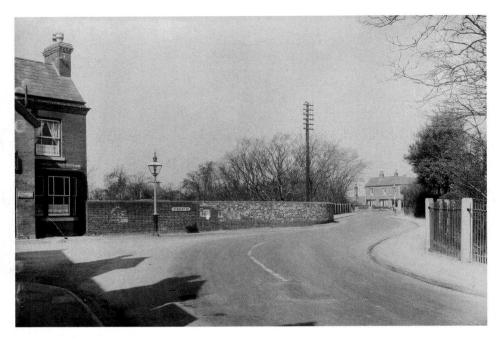

In Yardley Road, looking back to Mansfield Road, 1931. The house on the left was a weigh-house for goods arriving at the canal wharf here, which is now the Wynford Road Industrial Estate.

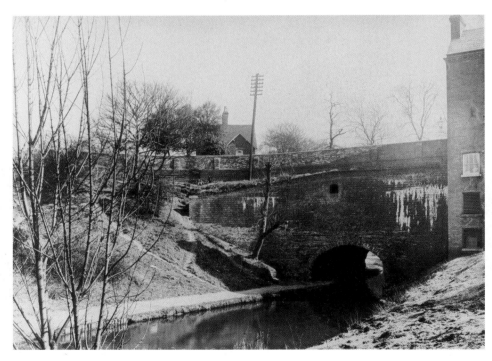

The Birmingham and Warwick Canal heading east under Yardley Road in 1931. The weigh-house was demolished a few years later when the tunnel was rebuilt.

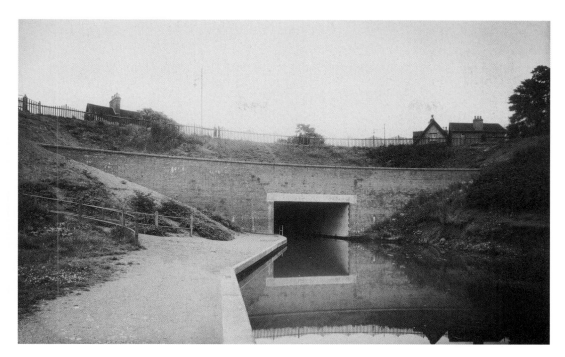

The new canal tunnel under Yardley Road, heading east, 1939.

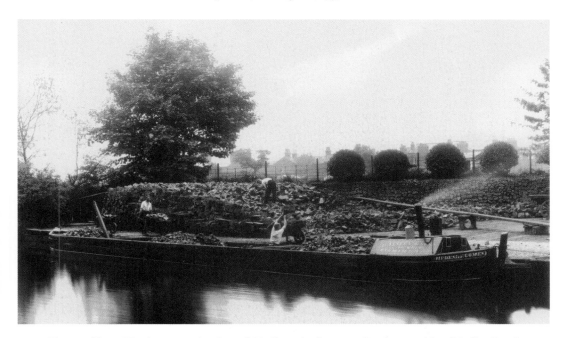

The canal boat *Hereshecomes* at the Co-op's Yardley wharf, *c.* 1930. On the east side of Yardley Road, it was opened by the Birmingham Industrial Co-operative Society in 1912 specifically for coal. The Birmingham and Warwick Canal linked to other canals bringing coal from the Cannock Chase and North Warwickshire coalfields. The houses in the background are in Francis Road.

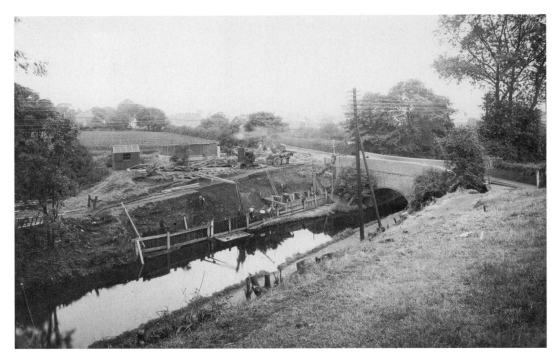

Widening the canal bridge at Stockfield Road, 1925. Going west, the canal passes through the industrial parts of Hay Mills and Tyseley.

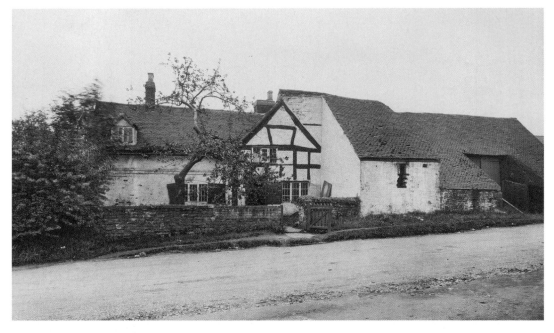

Stockfield Farm in Stockfield Road, 1925. Just south of the canal, it was lost to housing estates around Kilmorie Road. This hotchpotch of old buildings accumulated over the centuries.

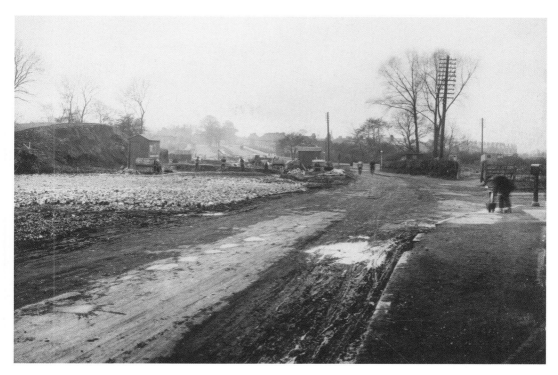

Widening Stockfield Road at the canal, 1925. This view looks south.

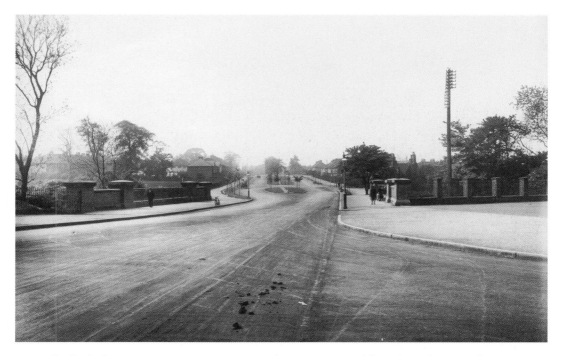

The finished project, 1930, improving access to the new estates and the industrial district of Tyseley.

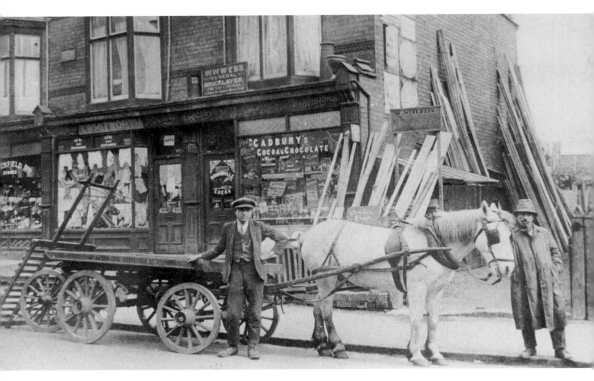

Above: William Webb the builder's yard, Stockfield Road, *c.* 1925.

Below: The north end of Stockfield Road, with Mansfield Road to the right, *c.* 1925.

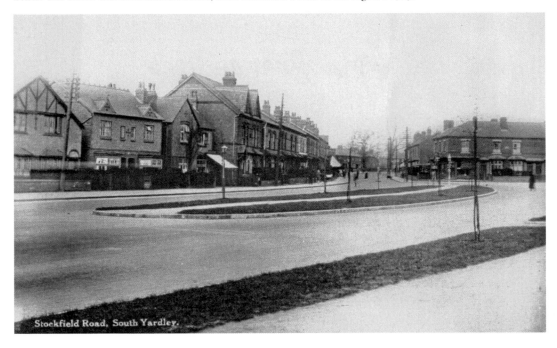

Stockfield Road, South Yardley.

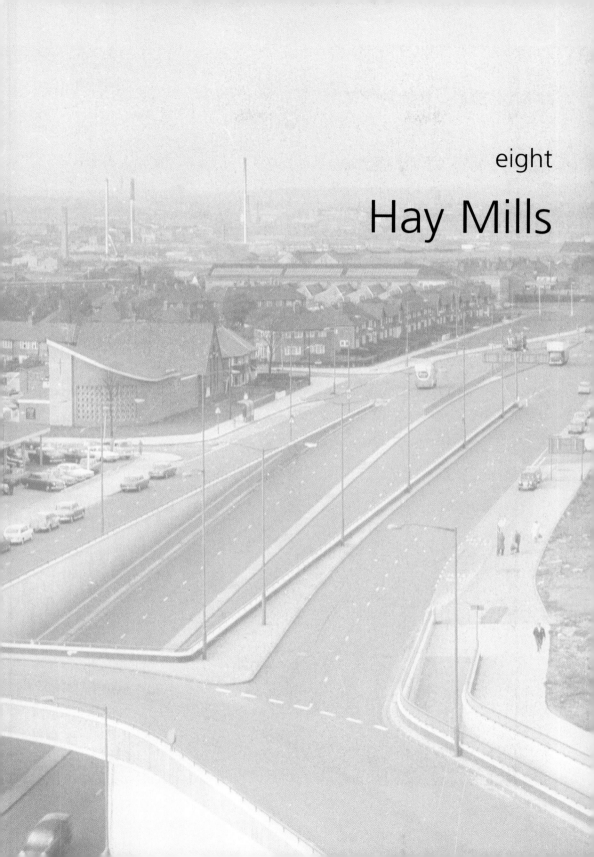

eight

Hay Mills

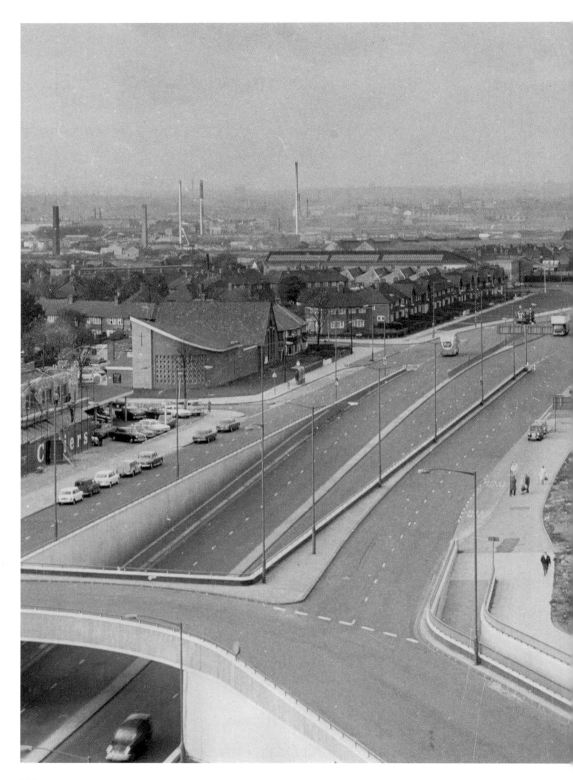

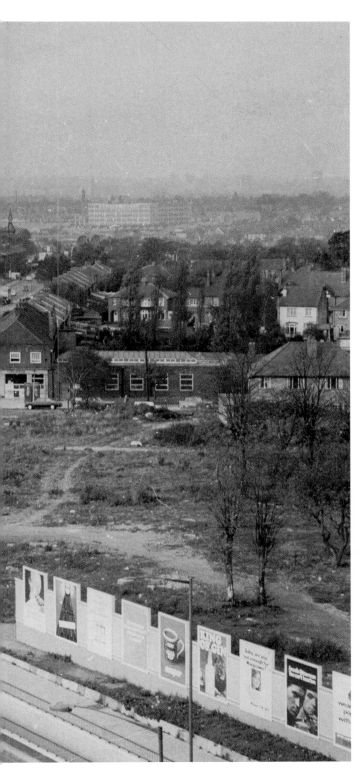

Aerial view of Hay Mills from Bakeman
Tower at the Swan, 1983.

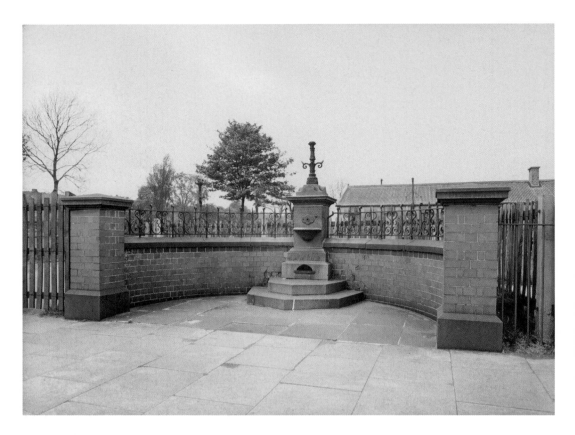

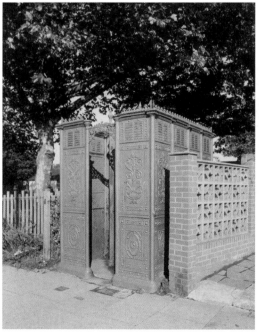

Above: Drinking fountain on the Coventry Road at the Oaklands Recreation Ground, 1957. It was donated in 1905 to Yardley District Council by Edwin Derrington, son of Josiah, who started the brickworks at Hay Mills. The prefabricated building behind was a wartime day nursery and opened in 1942. The vandalised remains of the fountain are still there.

Left: Public urinal near Derrington's fountain, 1984. These splendid examples of Victorian cast-iron work were once common in side streets of the central areas of Birmingham. Very few remain and this one was removed shortly after the photograph was taken.

Opposite above: View north along the Coventry Road, near Ada Road, 1927. There is an interesting display of period billboards left and right of the old cinema. The new Adelphi is being built behind it.

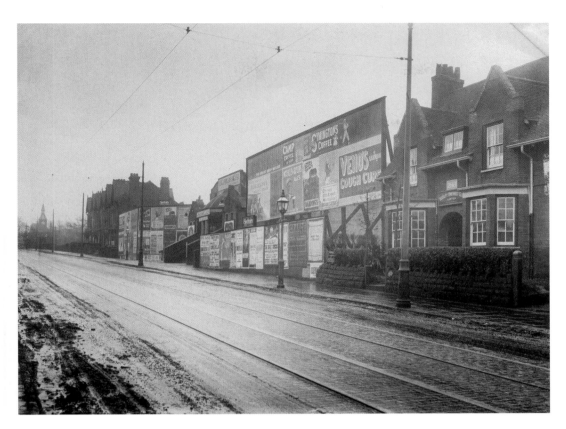

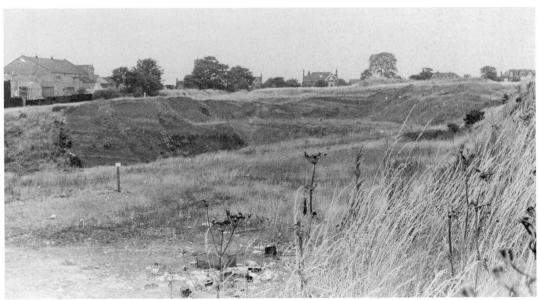

Clay pits near Ada Road, left by the Waterloo Brickworks, previously Bayliss', *c.* 1970. On the left is the rear of the Adelphi. Large warehouses have recently been put up on this site.

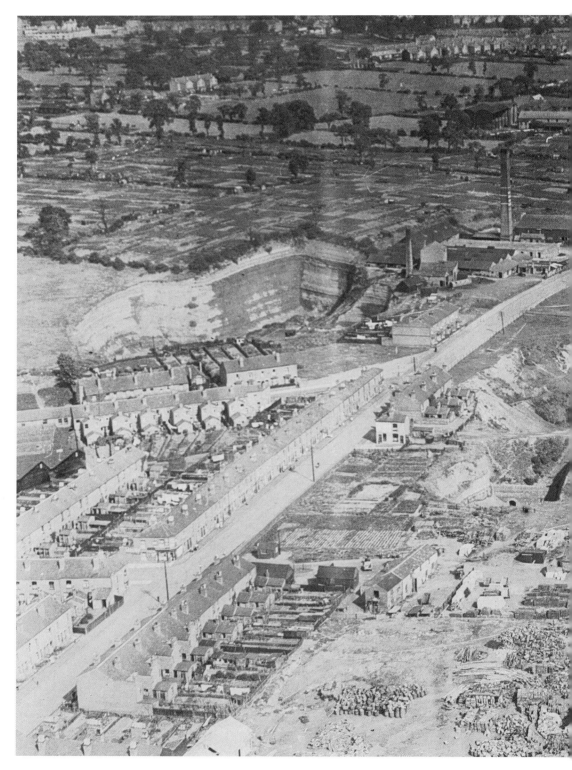

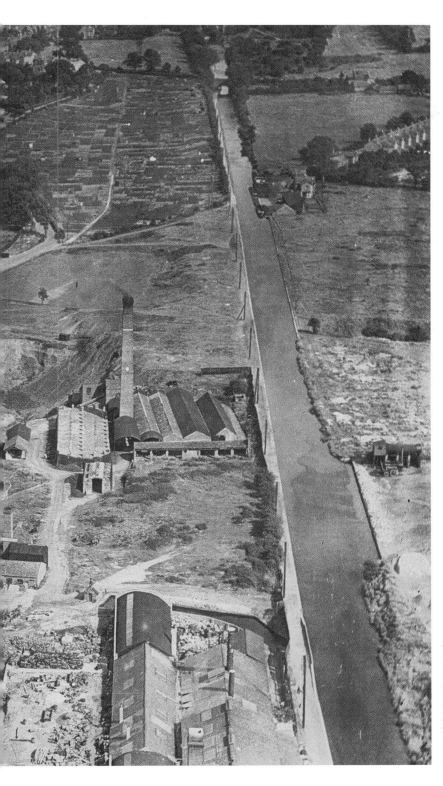

Aerial view of the brickworks at Speedwell Road, taken from a chimney stack, c. 1905. The Birmingham and Warwick Canal runs top to bottom on the right.

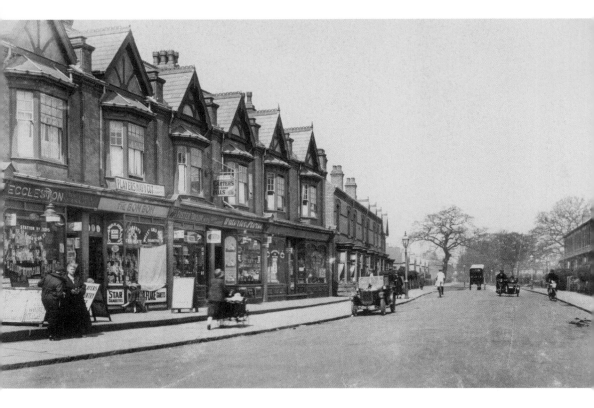

Above: Waterloo Road from Stockfield Road, *c.* 1920.

Left: Waterloo Road looking towards Stockfield Road (Graham Road is on the left), 1934.

Opposite above: Waterloo Road near the Coventry Road, 1934. The buildings in the centre are Waterloo Farm.

Opposite below: Kwikform's office, Waterloo Road, *c.* 1984. This was formerly Claremont, the home of Homer Muscott from the tannery.

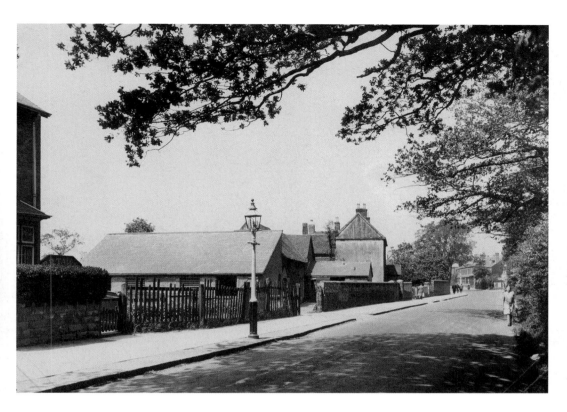

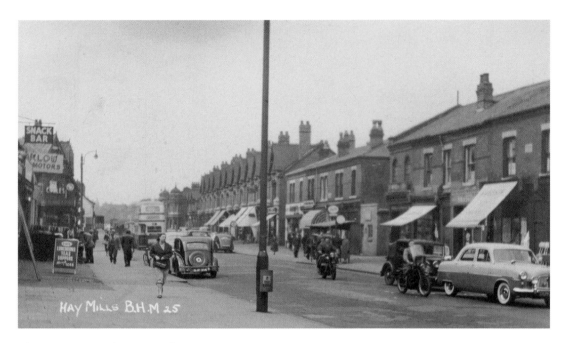

The Coventry Road at Hay Mills, heading to the River Cole, *c.* 1955.

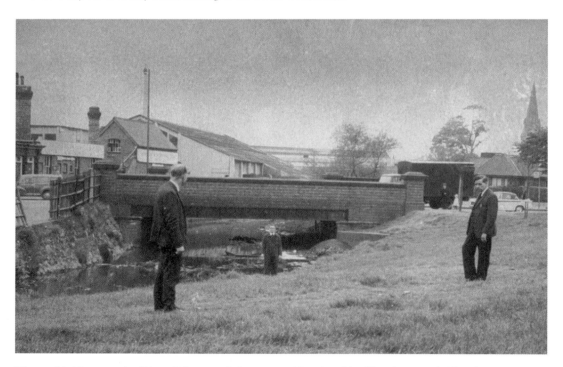

The road bridge over the River Cole, 1968. It is not surprising that this old and narrow bridge, dating from the early 1900s, could not cope with increasing traffic. Public Works staff are shown checking the site after a tractor drove into the river here.

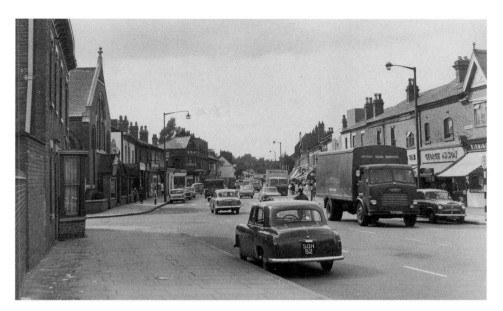

Hay Mills near the river, *c.* 1965. The buildings on the left were all lost to the road widening in the mid-1980s. The buildings on the right remain, many still occupied, but hardly flourishing as the new dual carriageway deters shoppers.

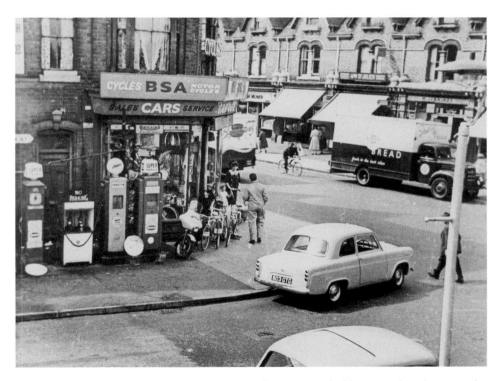

Cycle shop on the corner of George Road, *c.* 1984. These premises had been a cycle and motorcycle shop since the 1920s, with owners who believed in supporting local industry by stocking BSA bikes.

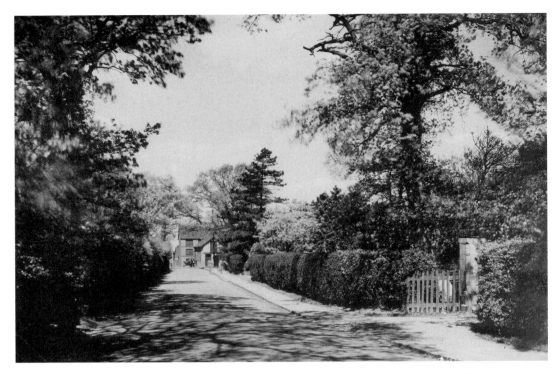

Amington Road from the entrance to Amington House on the right, 1934. In the distance is the tannery. This part of the road looks very rural, but beyond the tannery are the brickworks.

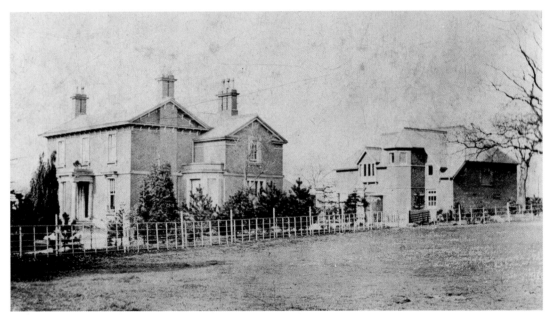

Amington House, c. 1910. This was the home of George Muscott, who took over the tannery in 1884 from Henry Homer who started it in 1802. It closed in 1966 and the site was sold to Wilmot Breeden Ltd.

Coronation party in Francis Road, 1953. Tyseley Metal Works is in the distance.

Unidentified Hay Mills wedding party, *c.* 1920.

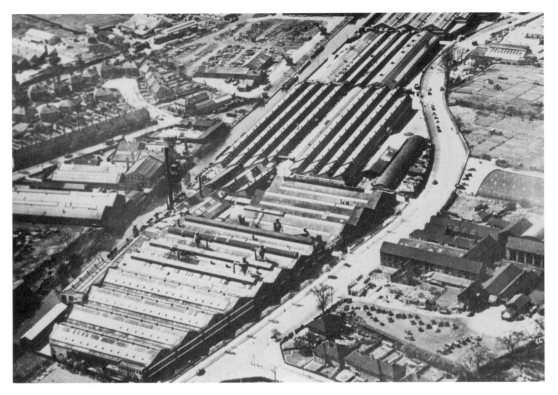

Wilmot Breeden Ltd's huge engineering works in Amington Road, *c.* 1950. The tannery is in the bottom right-hand corner. Brickworks used to occupy the factory site.

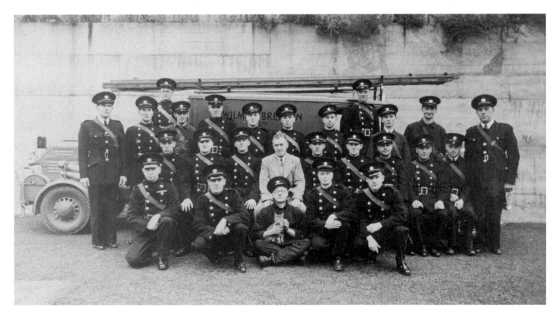

Wilmot Breeden's fire brigade, *c.* 1940.

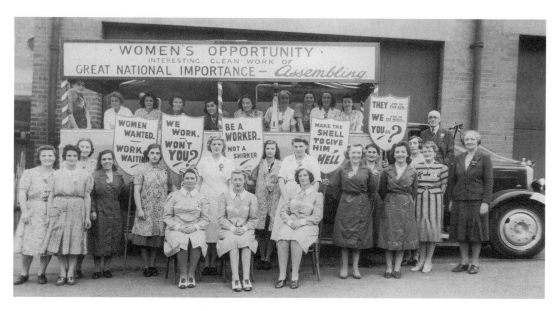

Female staff promoting war work for women, *c.* 1940.

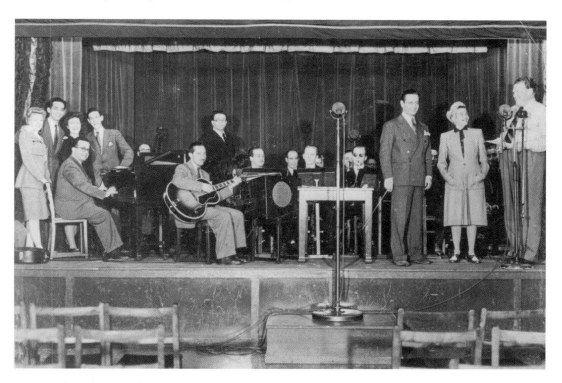

Workers' Playtime radio show at Wilmot Breeden's, July 1944, with Geraldo and his orchestra performing. The woman on the right is Bertha Wilmot, with Geraldo on the left and Brian Michie far right. *Workers' Playtime* visits continued until well after the war and were very popular morale boosters for factory workers all over the country.

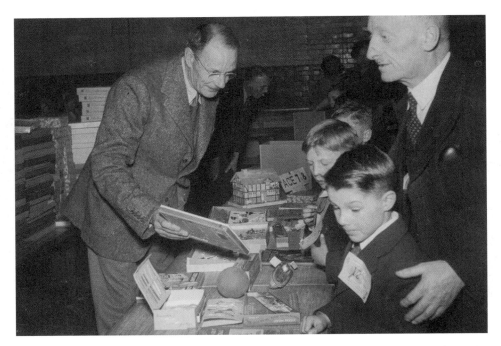

Employees' children choosing Christmas gifts, 1950. Wilmot Breeden provided extensive social activities for its workers. The sports club was well known for its amateur boxing, and there were regular dances for adults in the large staff canteen. Hundreds of children attended the Christmas parties.

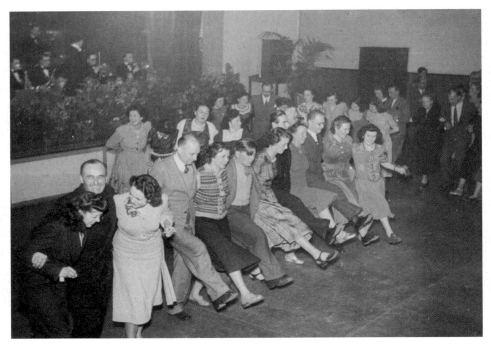

Doing the Hokey-Cokey, a light-hearted dance popular during the war, when fun was important.

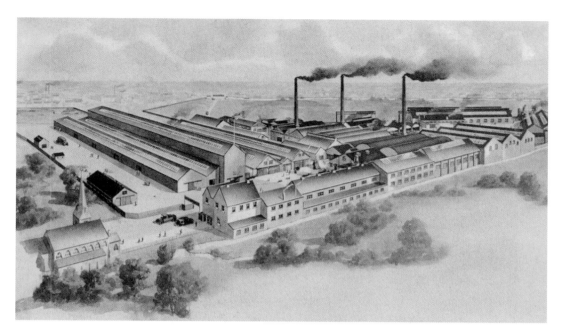

Webster and Horsfall's Wire Rope Works, c. 1870. James Horsfall first patented his steel wire in 1847 in Digbeth, and then moved to Hay Mills, amalgamating with Webster's of Penns Mill, Sutton Coldfield. The works, now better known as Latch and Batchelor's, still makes steel wire of all types, from piano wire to heavy industrial cables.

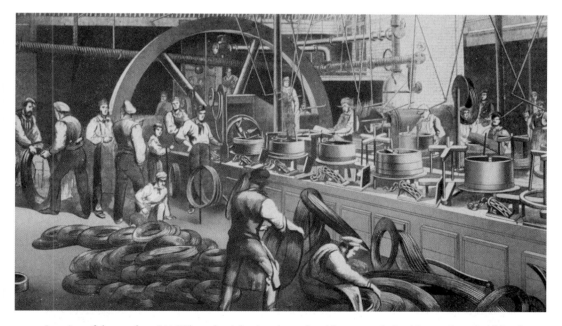

Interior of the works, 1866. When the Atlantic telegraph cable was made in this year, barrels of free beer were distributed to the workers to keep them going. Many employers in the heavy and hot industries accepted that their workers liked to drink and needed to do so to survive the conditions.

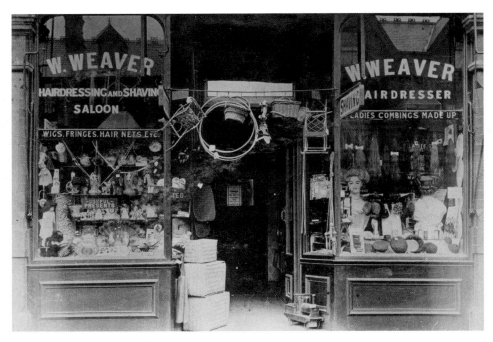

Weaver's hair salon at No. 1026 Coventry Road, *c.* 1920. William Weaver opened his first salon in the area at the turn of the century, and a salon with his name survived into the 1960s.

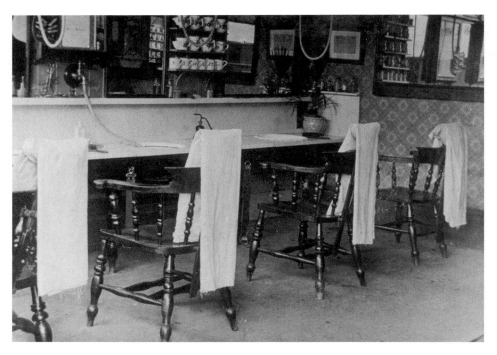

Inside Weaver's salon. Each chair has a leather strap on it, handy for sharpening the cut–throat razor used for shaving.

William Young's hardware shop, No. 1238 Coventry Road, *c.* 1930. On the corner of Flora Road, this was a proper, traditional hardware shop, so hard to find today, stocking every household necessity from gas mantles to step ladders.

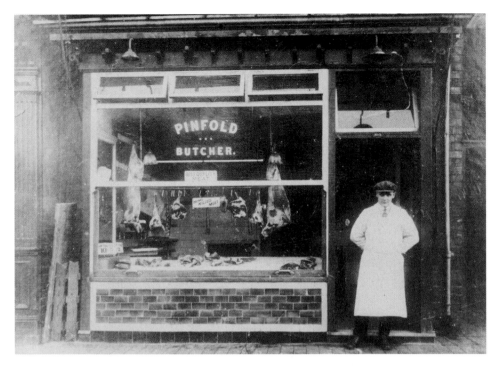

Edward Pinfold outside his butcher's shop at No. 1084 Coventry Road, *c.* 1930.

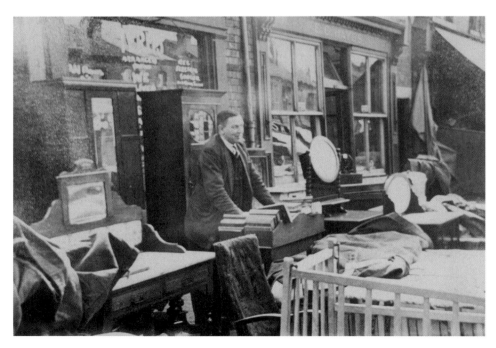

Glaze's second-hand shop at No. 1099 Coventry Road, *c.* 1930. The Glazes began as pawnbrokers in the early 1900s. Edward Haynes, next door, was a butcher.

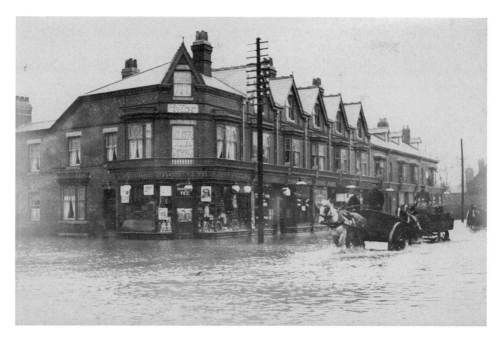

The River Cole in flood from Hay Mills Tavern to beyond George Road, 1904. Gilbey's Central Stores, on the corner of George Road, later became the cycle shop shown on page 113. The river frequently flooded as far as Kings Road, only stopping at Redhill.

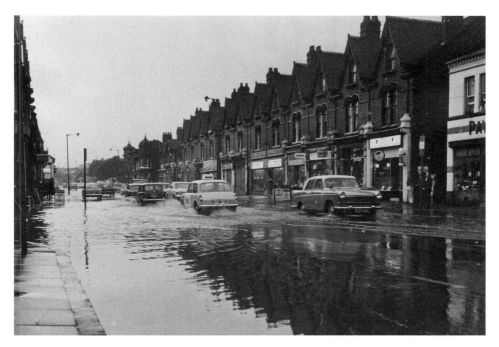

The Cole in flood looking towards the river, 1968. Flooding here only stopped when the river was culverted as part of the road widening in the 1980s.

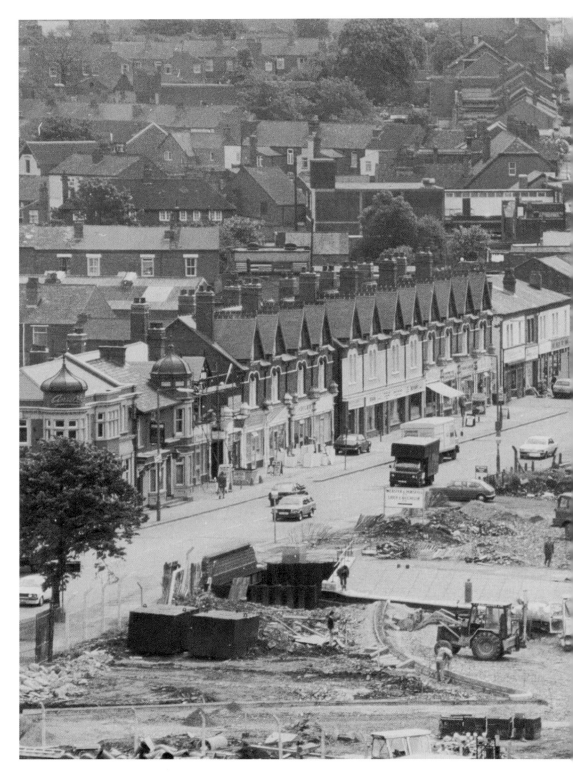

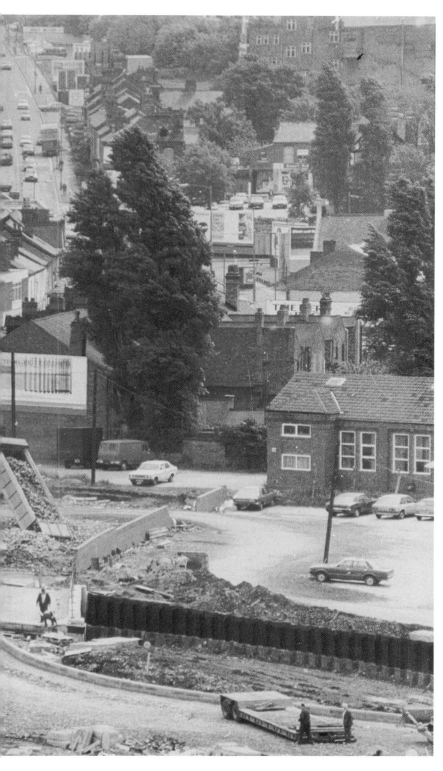

Aerial view looking up the Coventry Road, *c.* 1984. Probably taken from a crane, it shows work on widening the road at the river, and the construction of a roundabout to the Small Heath bypass. All the buildings on the right side of the road were demolished as far back as the Adelphi cinema, in the top right-hand corner.

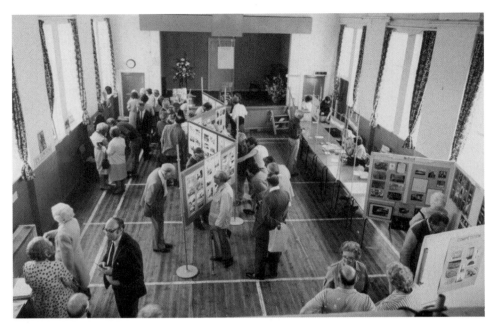

Inside Hay Mills Memorial Hall, 1984. An exhibition was put on to display the photographs of the area which were collected for the Hay Mills Project by local people when redevelopment began.

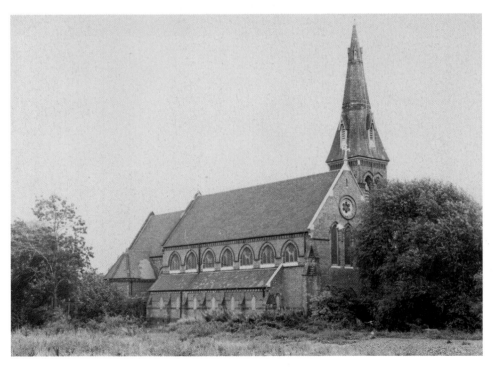

St Cyprian's church from the north, 1984. This view is hidden today by trees and shrubs alongside the Small Heath bypass which runs very close to this side of the church.

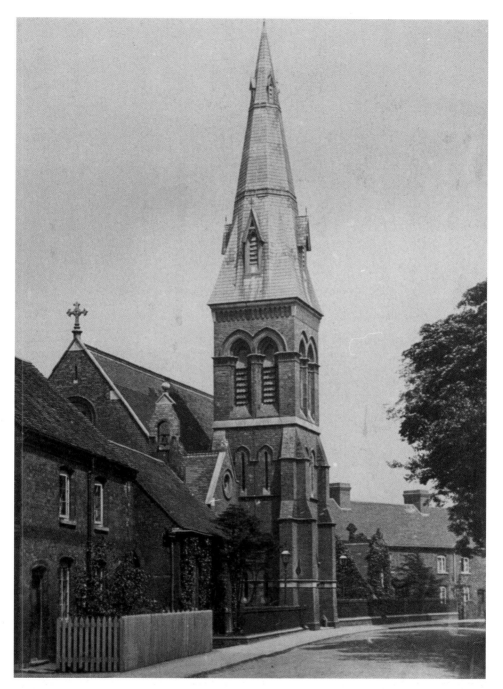

St Cyprian's church from the Fordrough, *c.* 1910. Built in 1873–74 by James Horsfall for his workers, it was for many years, because of its Gothic style, thought to be the work of J.H. Chamberlain and William Martin, architects of numerous Birmingham schools, libraries, churches and other public buildings. However, recent research has shown that the architect was the little-known Frank Barlow Osborn, although how the mistake came about remains a mystery.

Other local titles published by Tempus

Yardley

MICHAEL BYRNE

This fascinating sequence of archive photographs will bring back powerful memories for many people and introduce newcomers and a younger generation to a world of family run shops, horse-drawn vehicles and local industries that have now all but disappeared.

978 07524 0339 7

Birmingham Women

MARGARET D. GREEN

For many Birmingham women, the war years were a time of thrilling social change. In contrast with the limited nineteenth-century stereotype of the angel in the home, their essential contribution to war work gave them a taste for independence, with many wives and mothers becoming an integral part of the work force of the 'City of a Thousand Trades'. This book records some of their achievements during this period.

978 07524 2095 0

Around Sheldon

MARGARET D. GREEN

This fascinating collection of more than 220 archive images, many never published previously, explores the history of the Sheldon over the last century. Much has changed over that time and this nostalgic volume will delight anyone who has lived or worked in the town, providing a valuable social record of the way things used to be.

978 07524 3363 9

Birmingham Shops and Shopping

PETER DRAKE AND ANDREW MAXAM

It is an interesting fact that most of us can easily recall the shops we frequented as children – the faces of staff who served behind the counter, the fresh smell of a grocery shop or the reek of paraffin in a hardware store, all come flooding vividly back. This book of photographs will evoke a wealth of memories for Birmingham people as they are taken on a virtual tour around some of the city's old shops, many of which are now lost or only survive in a much changed state.

978 07524 4493 2

If you are interested in purchasing other books published by Tempus, or in case you have difficulty finding any Tempus books in your local bookshop, you can also place orders directly through our website

www.tempus-publishing.com

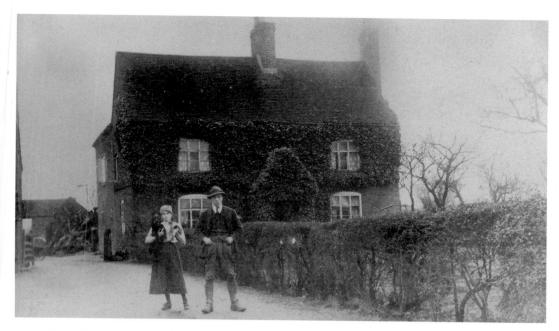

Above: The two photographs on this page remind us of King's Heath's rural past. Pictured here are Edwin and Daisy Greves outside Woodthorpe Farm, which stood at the top of what is now Sunderton Road. The Greves family also farmed at Southern Farm (opposite Hannon Road) and Malthouse Farm (next to Cocksmoor leisure centre); their associations with King's Heath date back to the 1850s.

Below: Alcester Road as it heads up towards Millpool Hill. The Horseshoe pub is just behind the trees on the left.

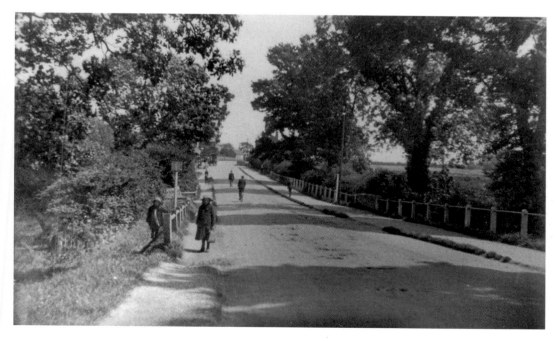

Other local titles published by Tempus

Birmingham Shops and Shopping
PETER DRAKE AND ANDREW MAXAM

Like most big cities, Birmingham has lost many of its family-owned shops, department stores and Co-ops in recent decades. Illustrated with more than 190 photographs from the archives of Birmingham Central Library and from private collections, this book offers a unique glimpse into Birmingham's commercial past.

978 0 7524 4493 2

Birmingham and the Chamberlains
PETER DRAKE AND PAUL HARRIS

The Chamberlains – father Joe and sons Austen and Neville – are probably the country's best-known political family. Synonymous with Birmingham, they achieved both local fame and fortune. Together, they transformed late Victorian Birmingham into 'the best-governed city in the world'. This work provides a fascinating insight into the Chamberlain's legacy

978 0 7524 4492 5

Newton and Summer Lane
PETER DRAKE AND JON GLASBY

This book seeks to rectify a curious anomaly in the published records of Birmingham's history: references to Summer Lane and Newtown are rarely seen in published accounts of the city. The book also includes a pictorial account of a leading Birmingham voluntary organisation known as the Birmingham Settlement. It will be an important record for those who have lived and worked there and it will put on the historical map an area that has until now been largely neglected by the historians.

978 0 7524 4197 9

The Roots of Tolkein's Middle Earth
ROBERT S. BLACKHAM

J.R.R. Tolkien, creator of the fictional world of Middle-earth and arguably one of the most influential writers of the twentieth century, grew up and spent his formative years in the suburbs of Birmingham. His memories of the area were later to become a valuable source of names, images and settings for his literary creations, now immortalised for millions in *The Hobbit* and *The Lord of the Rings.*

978 0 7524 3856 6

If you are interested in purchasing other books published by Tempus, or in case you have difficulty finding any Tempus books in your local bookshop, you can also place orders directly through our website
www.tempus-publishing.com